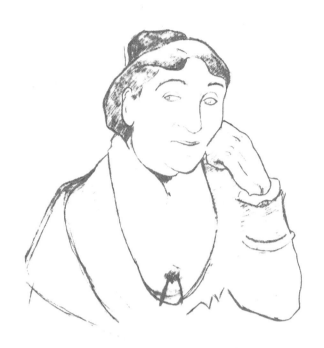

P Gauguin.

Ingo F. Walther

PAUL GAUGUIN
1848–1903

The Primitive Sophisticate

THUNDER BAY
P·R·E·S·S

FRONT COVER:
Detail from: When Will You Marry? (Nafea Faa Ipoipo?), 1892
Oil on canvas, 101.5 x 77.5 cm
Rudolf Staechlin Collection,
Kunstmuseum Basel, Basle

FRONTISPIECE:
Bonjour, Monsieur Gauguin, 1889
Oil on canvas, 113 x 92 cm
Národni Gallery, Prague

BACK COVER:
Detail from: **Caricature Self-Portrait, 1889**
Oil on wood, 79.2 x 51.3 cm
National Gallery of Art, Washington

Published by Thunder Bay Press
5880 Oberlin Drive, Suite 400
San Diego, CA 92121-9653
1-800-284-3580
Library of Congress Cataloging in Publication Data available on request.

© 1997 Benedikt Taschen Verlag GmbH
Hohenzollernring 53, D-50672 Köln
English translation: Michael Hulse

Printed in Germany
ISBN 1-57145-097-1

97 98 99 00 1 2 3 4

Contents

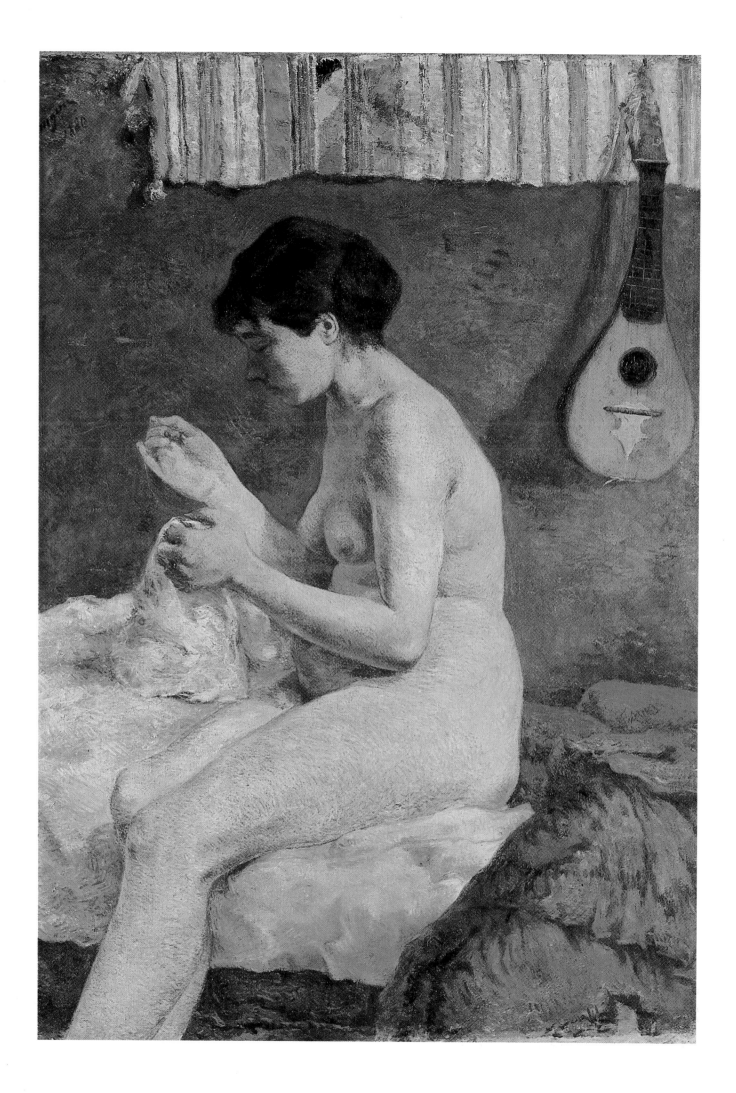

The Age of Impressionism
1848–1887

There cannot have been many other artists who set out as wholeheartedly to live the life they envisioned in their art as Paul Gauguin did. He lived between two worlds. In this art he held up a mirror to his own civilization, which he despised, and showed an alternative, primitive life in all its simple, naïve harmony. But painting it was not enough for Gauguin. He wanted to experience it himself. He wanted to prove that South Sea exoticism was not merely a forced and magical escapism, of the kind that was fascinating his European contemporaries in an age of world fairs and newspaper reports. Gauguin personified a new union of art and life, imagination and order, and in anticipating this predominant 20th century characteristic he became one of the true pioneers of modernism.

Gauguin discovered his artistic bent relatively late. When he made his break with comfortable middle-class life, he already had a wife, a family, and a small fortune. In making the break he liked to see himself as an unconventional anti-hero, forging ahead on his own, indifferent to the recognition of his fellow-men. But much as he would have liked to despise the *bourgeois* world, Gauguin the outsider still hankered after the success which Gauguin the stock market speculator had formerly achieved. As his failure became ever deeper, he became a wrathful critic of that European civilization which ignored him, and in the end even took to actively resisting the colonial administration in Tahiti.

Gauguin's artistic models were Giotto, Raphael and Ingres, and the literary tradition he valued was that of Montaigne and Rousseau, who had considered the circumstances of the colonial peoples and gone on to accuse their own civilization of thinking too highly of itself and indeed of being megalomaniac. The "noble savage" was the better human being because he was more contented and dwelt at peace with Nature. And that automatically meant he led a happier life. It was that happiness that Gauguin was seeking.

Gauguin's dreams of escape, though resigned and melancholy, were not without an element of shrewd calculation. He shared his longing for a distant paradise with the whole of high society. When he sprang his exotic pictures on an unsuspecting public, he was not only showing the sources of his inspiration: he was also indicating the sources of his income. Rolling up his canvases and sending them in

Portrait of Gauguin's Daughter Aline, ca. 1879/80
Watercolour, 18.6 × 16.2 cm
Private collection, Basle

Study of a Nude. Suzanne Sewing, 1880
Oil on canvas, 115 × 80 cm
Ny Carlsberg Glyptotek, Copenhagen

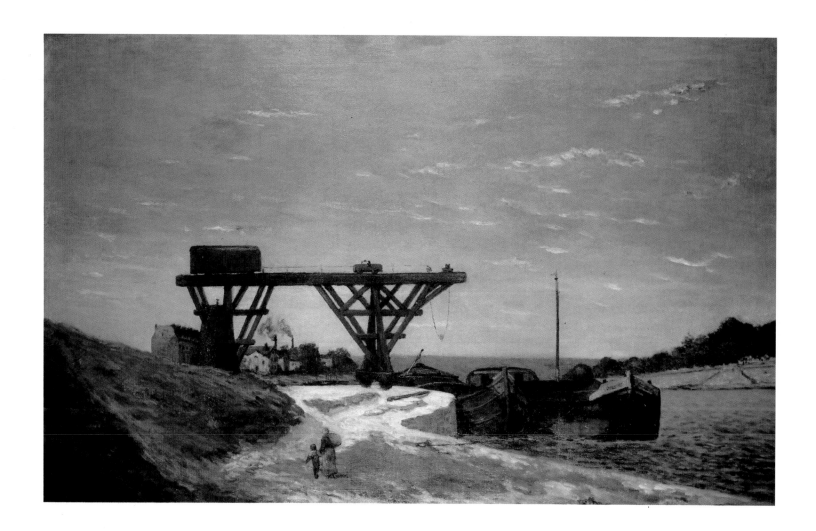

The Seine in Paris between the Pont d'Iéna and the Pont de Grenelle, 1875
Oil on canvas, 81 × 116 cm
Private collection

secure packages from Tahiti to France, to adorn the walls of European salons, he was no less the *bourgeois* than when he urged his son to take to a useful career, such as that of engineer, rather than the penury of an artist's life. "He is a tremendous businessman, or at least he thinks like one," Camille Pissarro once said. And at heart Gauguin remained a businessman his whole life long. Whatever his intentions, he had been subjected to the same education as his contemporaries, conditioned to compete and to uphold the norms and orderly values which were sincerely believed to be for the best, and which damned him to failure the moment he began. Just as nations sought out peoples they could subjugate and colonize, so Gauguin needed conquests, for his own sake and for his art.

In November 1873, aged twenty-five, Gauguin married a young Danish woman called Mette Sophie Gad in Paris. He had travelled far and wide as a sailor. She was a children's nanny. Longing for security (on his side) and a fascination with travellers' tales (on hers) had brought them together, but the marriage was flimsy and did not survive Gauguin's discovery of his artistic talent. Though he and Mette did not divorce, they duly went their separate ways.

But at first their household flourished. The young wife could afford major purchases because Gauguin was earning good money at the stock exchange. They had five children — Emile, Aline, Clovis, Jean René and Pola — and doted on them all. The doors of Parisian high society were presently opened to them, and Gauguin — behaving as

his social standing required — began to collect Impressionist paintings. It was not very long before he took up painting himself, as a hobby. He studied the old masters in the Louvre together with another painter, Claude Emile Schuffenecker. In his own unambitious works he chose to depict scenes of family life.

The Seine in Paris between the Pont d'Iéna and the Pont de Grenelle (p. 8) is one of the earliest paintings in which Gauguin abandons the subject of idyllic family life. It is a tranquil and atmospheric Sunday scene. No one is working, and the crane which dominates the picture seems forlorn. The sky is peaceful and blue, the two figures in the foreground are doing nothing to disturb the sense of quiet, and the very barges and houses look sleepy! In this painting we see Gauguin toying with Impressionism, albeit tentatively. Impressionism was the major art movement of his time, and its hallmark was unemotional scrutiny of a busy, lively world. Gauguin, by contrast, appears to be fixing his attention on lack of emotion itself. Impressionism liked to set its images adrift in a shimmering sea of light. Gauguin, by contrast, highlights a personal love of static detail. The mood of the painting remains cool, and the painter himself distant.

Consistently enough, when Gauguin came to exhibit one of his paintings for the first time it was not alongside the Impressionists but

Aubé the Sculptor and His Son, 1882
Pastel, 53 × 72 cm
Musée du Petit Palais, Paris

Study for The Bathers, 1886
Black chalk and pastel, 57.3 × 34.7 cm
Art Institute of Chicago, Chicago

at the official *Salon.* The *Salon* was notorious for its conservatism amongst the group of young artists led by Edouard Manet und Claude Monet. Only three years later, though, at Pissarro's lively encouragement, Gauguin did exhibit with the Impressionists. There he encountered that rejection of traditional middle-class notions of art which he was to espouse time and again in the years ahead. Gauguin continued to work at the stock exchange. But the provocative and novel stance adopted by the Impressionists sharpened his own critical faculty. And he became a success, showing seven canvases at the annual Impressionist exhibition in 1880.

Study of a Nude. Suzanne Sewing (p. 6) is a thoroughly Impressionist work in its use of dynamic light effects produced by innumerable thin brushstrokes. The writer and art critic Joris Kar Huysmans, a contemporary of Gauguin, spoke of the "little creases below the bosom, which is highlighted by dark patches and seems to be doing some wild dance". It is as if a nervous, colourful element had been introduced into a wholly static subject, a subject which hardly seems Impressionist in character at all. The naked woman seated at her work possesses a quiet dignity that awakens no shameful responses, and the way in which Gauguin has perceived her anticipates his later attempts to capture the calm but powerful presence of the South Sea peoples. It is true that Gauguin made use of Impressionist methods. But he did not share their view of the world, or their emphasis on dynamic flux.

In November 1882 a stock market crash put an abrupt stop to Gauguin's double life as broker and artist. The crash cost him and his friend Schuffenecker their jobs. And it left Gauguin free to indulge in the wayward life of a dandy to his heart's content. He had always longed for the bohemian existence that suddenly became available to him; but the snag was that now he had a family to care for, five children to feed, and a house. None of this fitted in with the image of a drop-out adrift in the big city. As if to prove that artists *could* be responsible family men, he painted his double portrait of *Aubé the Sculptor and His Son* (p. 9) the very same year. The boy who is naturally destined to follow in his father's footsteps and is drawing on a sketch-pad, and the artist wholly absorbed in this work, together show that a cosy family idyll and independent creative labour are compatible. But Gauguin was no sculptor. Nor was he an Aubé.

At any rate, Mette, unable to share her husband's euphoric view of art, went to stay with her parents in Denmark. Gauguin felt obliged to look for another remunerative job, but his quest was half-hearted, the economic climate poor, and so he was unsuccessful. For a while he worked as a sales representative for a French textiles firm, in his wife's home town, Copenhagen. But all he got out of his northern venture was an exhibition of his paintings, and it was a disaster. "I deeply loathe Denmark, and the Danish people, and the Danish climate," he wrote, and soon returned to Paris. His family, which saw him as a ne'er-do-well, stayed behind, though Gauguin was accompanied by his son Clovis and had to provide for him out of his income as an artist.

Cattle Drinking, 1885
Oil on canvas, 81 × 65 cm
Galleria d'Arte Moderna, Milan

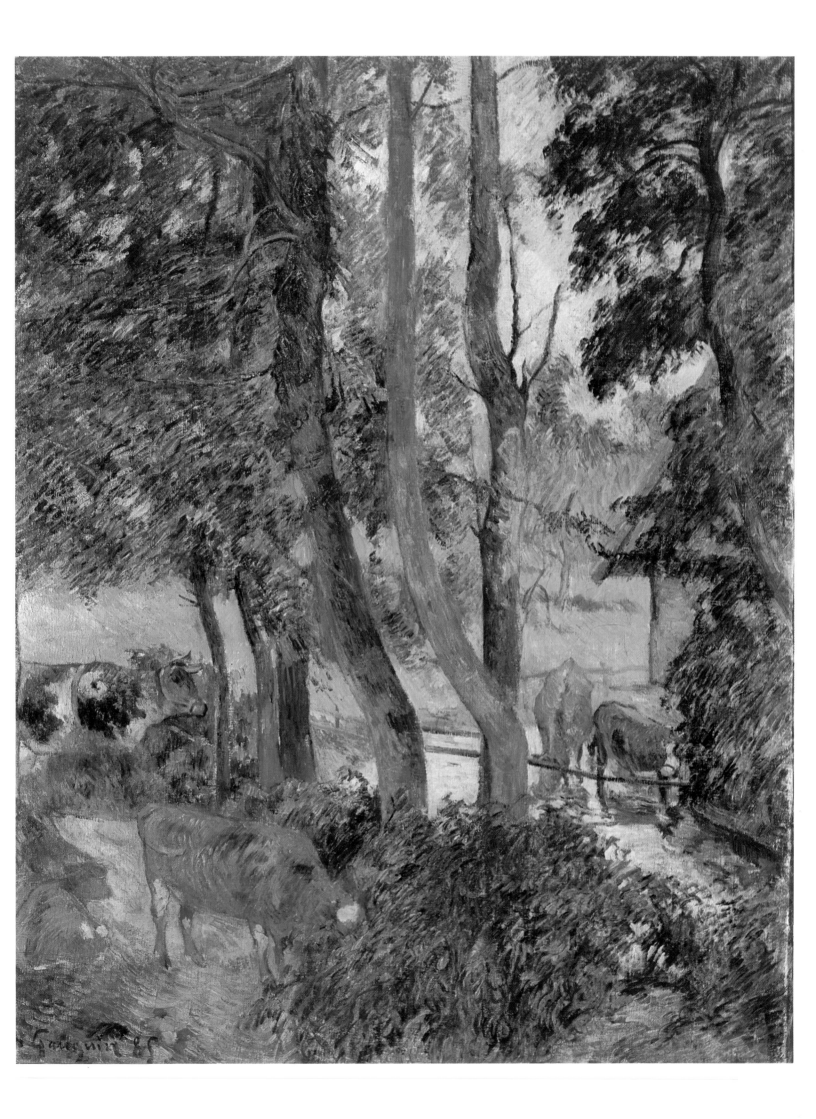

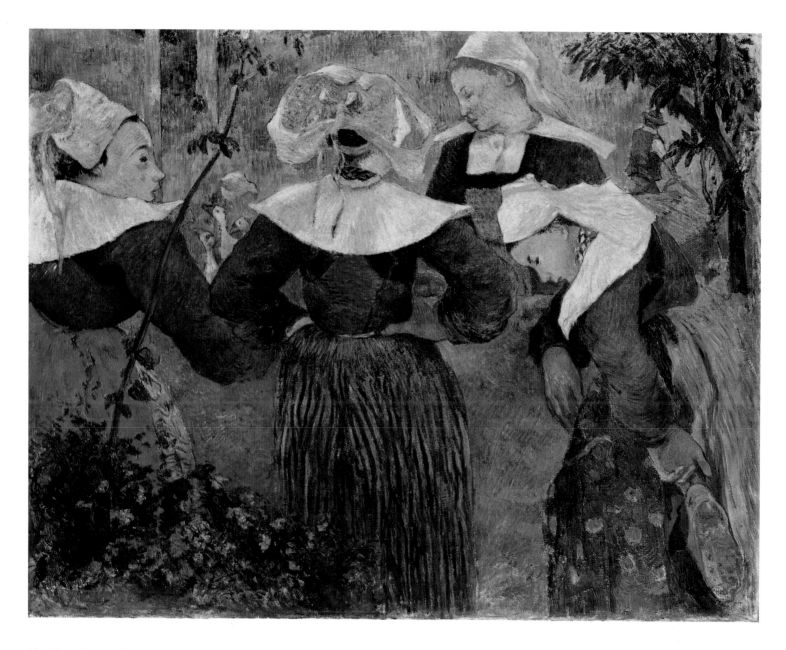

The Four Breton Girls, ca. 1886
Oil on canvas, 72 × 91 cm
Neue Pinakothek, Munich

"When the lad had his attack of smallpox I had just twenty centimes in my pocket," Gauguin wrote to his wife from the depths of the Parisian winter. His tone was resigned, but also betrayed the spiteful condescension of the misunderstood genius who blamed others for his own misfortunes. He had not sold a single painting, and was earning a miserable five francs a day pasting up posters. He had longed to drop out of his *bourgeois* career, but when the time came the move was unplanned and proved unsuccessful. Escape into the bohemia of dandies, pleasure-seekers and self-proclaimed artists had cost him dearly. When his flight into the city's sub-culture had turned out to be a failure, Gauguin contemplated retreat to the country.

In summer 1886 Gauguin moved to the little village of Pont-Aven on the Atlantic coast of Brittany, "where you can live on next to nothing". He had sent his son Clovis back to Denmark, to his mother — indeed, to put it baldly, he had got rid of the boy. By now it was not only a middle-class career that seemed beyond his powers; he even felt unequal to being a father. He compensated by plunging all the more energetically into his artistic labours. At Madame Gloanec's boarding

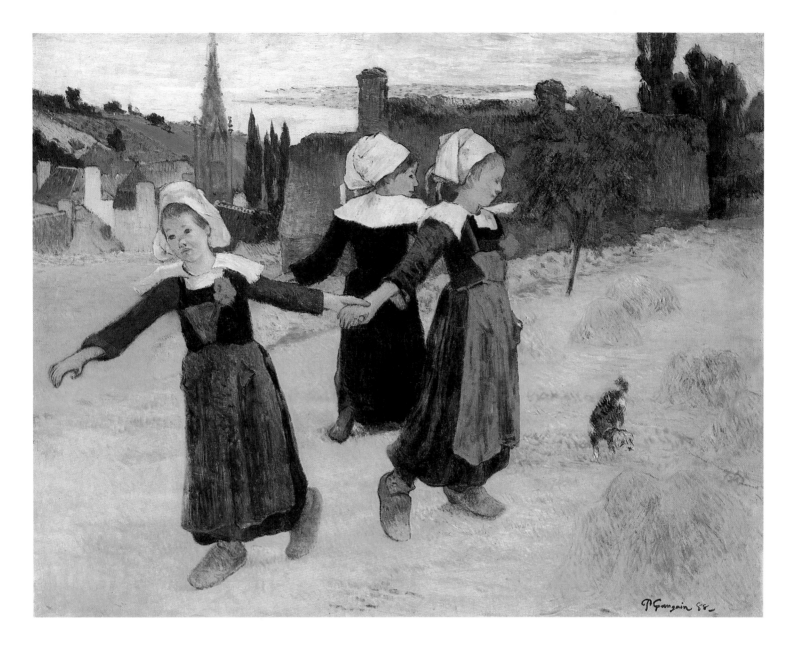

Breton Girls Dancing, Pont-Aven, 1888
Oil on canvas, 73 × 92.7 cm
National Gallery of Art, Washington

house he attracted like-minded young artists who were tempted by the region's spartan beauty and an inexpensive life. Now he could at least write to Mette that he enjoyed recognition as a painter: "I am working well here and successfully. They respect me as the best painter in Pont-Aven. Respect won't earn me a single centime, true. But my reputation is excellent, at any rate, and everyone wants my advice." Gauguin was still very poor, but at least he was increasingly confident.

In *The Four Breton Girls* (p. 12) we see him relying wholly on a quality of monumental simplicity in his subject. Folk costumes and dance show his interest in the uncomplicated rustic life of Brittany, while the painting's colourfulness still owes a good deal to the shimmering effects of Impressionism. What is newly important in this work is a sense of static equilibrium and poise, conveying such calm that the movements of the dance seem arrested. In his future work, Gauguin was to emphasize major form, and firm, upright lines that define shape and contour were to be its characteristic hallmark. The silhouetted faces of three of the women already bear traces of this.

In 1886, Gauguin exhibited no fewer than nineteen paintings at the Impressionists' salon. This was ironical. While Monet was painting the

glittering diversity of city life, Gauguin had gone in the opposite direction, in search of tranquillity. Furthermore, Gauguin was upstaged at the salon by Georges Seurat, who exhibited his massive *Sunday Afternoon at the Ile de la Grande Jatte.* In this work, Seurat underpinned Impressionist approaches with theoretical principles of perception. Both Seurat and Gauguin were questing for major, inviolable form, in their different ways, but Seurat was using the refined means of civilization in his attempt, while Gauguin was impelled to look elsewhere, hoping to find what he sought in primitivism.

After Brittany, Gauguin intended to escape for good by making for the unspoilt simplicity of the tropics. None too sure of his plans, he decided to start in Panama, where the building of the Canal promised a livelihood. A friend called Charles Laval, one of the Pont-Aven painters, accompanied him. As so often, however, Gauguin's skills were unwanted in Central America too, and the two friends, somewhat rudely awakened, moved on to the French island colony of Martinique in the Caribbean.

At the Pond (p. 15) was painted there. Gauguin's feel for the brightness of colours had a new sensitivity, and the picture finds him continuing his efforts to use Impressionist methods of applying paint when tackling motifs of some dignity. Here once again the most important elements in the composition — the trees on the centre axis, the animals — were highlighted, marked out against the colourful confusion of bright lines that remains predominant. And at last Gau-

Breton Girls Dancing, 1888
Pastel on paper, 24.2 × 41 cm
Rijksmuseum Vincent van Gogh, Amsterdam

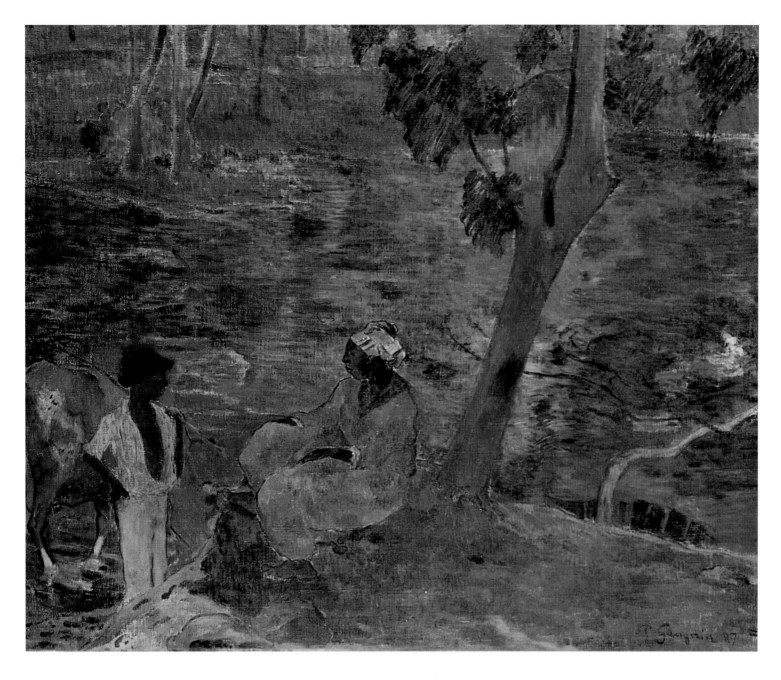

At the Pond, 1887
Oil on canvas, 54 × 65 cm
Rijksmuseum Vincent van Gogh, Amsterdam

guin had discovered an instinct for colour. The intense sun of Martinique gave him a sense of the resplendent brightness of colour which Brittany could never have offered him.

Gauguin's love of the tropics may have been an escapist flight from civilization, but it was also an attempt to rediscover the happiness of his South American childhood.

Born in Paris, Paul Gauguin had gone to Peru with his family at the tender age of one. His parents had strong republican convictions and when Louis Napoléon returned to France they quit the country. Peru was the home of Gauguin's grandfather, a hundred-year-old survivor with the evocative name Don Pio Tristan Orosco, and doubtless the old man made an unforgettable impression on the infant Paul. At all events, Paul Gauguin was fascinated by everything exotic from his childhood on. Though his family returned to France in 1855, Gauguin betrayed a hankering for foreign parts in his youth, and went to sea as a sailor. In a sense, his settled years of *bourgeois* life from 1872 to 1882 were merely an interval of quiet along his restless way.

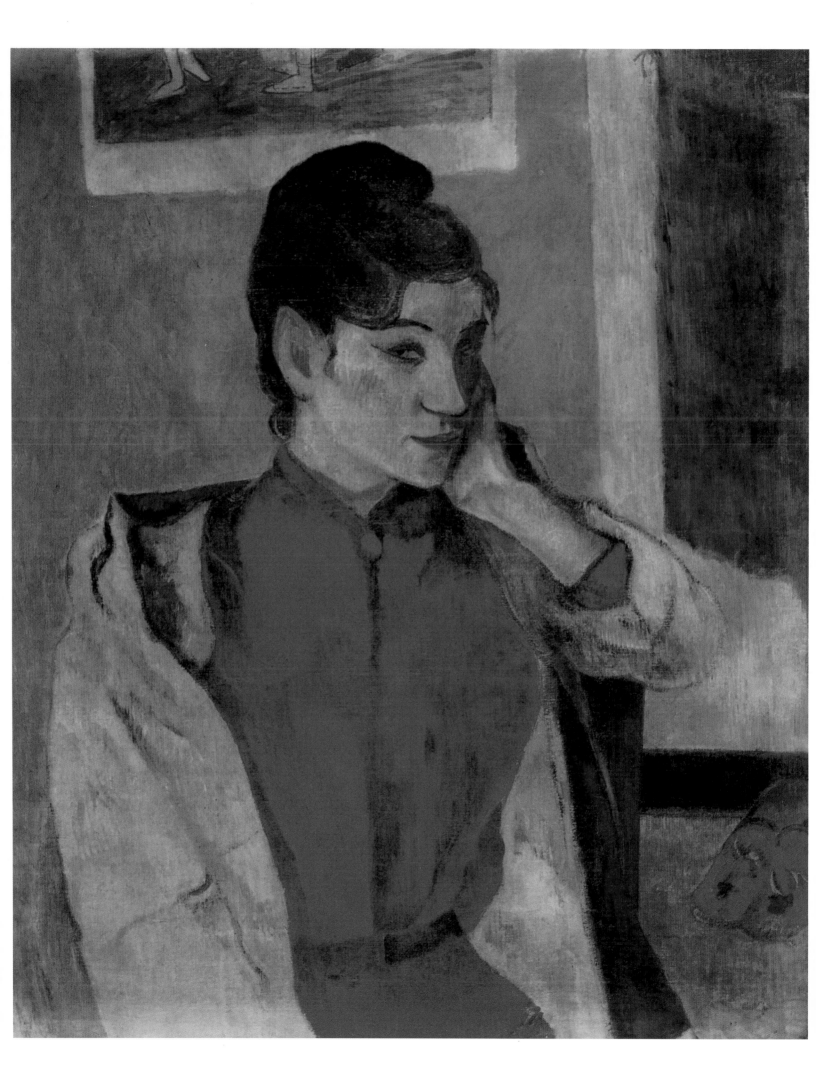

Suggestion and Expression
1888–1891

The year 1888, when he returned to France, was to see Gauguin's most decisive artistic progress. As he himself attested: "This year I have sacrificed everything, all my technique, all my colour, to style." Finally he broke free of the urbane world of Impressionism. In the peasant simplicity of provincial life he not only discovered an inexhaustible source of subjects but also began to take his own artistic bearings from the unaffected originality of folk art.

The age of the great world fairs, entranced by prospects of progress and a future of technological well-being, was not without its awareness of an alternative world of peace and harmony which industrialization threatened with extinction. That other world was elsewhere; not in the urban civilization of the modern cities but in provincial backwaters and above all in the unspoilt reaches of faraway continents. *Bourgeois* society was tirelessly hardworking and had grown rich through its efforts. But it was intoxicated by visions of remote and magical worlds – as long as they stayed remote. Art was just the place for such visions. Paintings took to wearing exotic garb and showing mysterious and colourful things which excited the public's longings. The world of these paintings was artificial; it was a sensational world as far from the reality of the tropics as the tropics were from Paris.

Gauguin too had fallen under the spell. In his art, however, he aimed to portray a primitive world on its own terms, stripped of exotic props and without the cottage romanticism of peasant idylls. He was out to show the genuine, unposed, original character of subjects drawn from an unfamiliar, simple world. If the impression they made was also one of rudimentary crudeness, so be it; their very lack of refined sophistication was the guarantee of their authenticity.

During his quest for a primitivist method in Brittany, Gauguin had hit upon a new style: Cloisonnism. He developed this style at Pont-Aven together with one of his fellow-painters, Emile Bernard. The name came from a mediaeval enamelling technique in which the individual surfaces were compartmented off in fillets of metal. Similarly, the two painters took to contouring all their colour surfaces with thick lines of colour, with a rigour that verged on the dogmatic. The graphic line acquired as distinct a visual value as the area it encompassed. Naturally it was still representational art, and the lines and surfaces still clearly depicted recognizable figures and objects; but at the same

Head of a Negress, 1887
Pastel, 36 × 27 cm
Rijksmuseum Vincent van Gogh, Amsterdam

Madeleine Bernard, 1888
Oil on canvas, 72 × 58 cm
Musée de Peinture et de Sculpture, Grenoble

Natives, Martinique, 1887
Watercolour, 20.9 × 26.8 cm
Private collection, Basle

time a kind of abstract pattern was superimposed on the canvas, and the lines and surfaces took on an independent existence of their own. Quite apart from its representation of reality, a painting's union of fabric and paint, lines and surfaces, figures and decorative content, had to suggest a world beyond what was immediately apparent, just as the Bretons' Celtic ancestors had represented their gods in abstract, ornamental form as entangled strands. The deeper and more harmonious world must remain hidden and invisible. It could only be felt, or sensed associatively.

"I should like to keep as much distance as possible from the creation of illusions," said Gauguin, in explanation of the coolly analytic gaze he directed to what lay beneath the surface of things. The strategy he adopted to avoid creating illusions is apparent in his *Still Life with Three Puppies* (p. 19). The still life consists of fruit, glasses, and puppies drinking from a bowl. The objects in the painting are familiar enough; yet within the new context they are subverted and destabilized. The table top on which they are placed looks unequal to the business of maintaining balance, and is seemingly being pulled down by some mysterious force. This has the effect of making the juxtaposition of objects look like a mere heap. It does not detract from the spatial solidity of the glasses, apples and pears, though, and they have a firm and even palpable quality. If the individual elements are thoroughly ordinary, though, the composition of the picture is distinctly unusual; and it is only in reference to the top edge of the canvas, which robs us of any logical sense of spatial dimension, that we can see the point in this composition. The visual motifs become components in a decorative whole: the three glasses provide a rhythmic counterpoint against the white of the table-cloth, and the three puppies pick up the rounded shape of the bowl. The decorative embroidery on the linen cloth can be seen as a basic pattern for the whole painting, which constitutes a single decorative piece. Its forms are taken from visible reality, but they have undergone a creative process that has fitted them into an abstract scheme.

Gauguin had borrowed this tendency to ornamental arrangement from Japanese woodcuts. The vogue for the exotic which raged at the time extended to Oriental art, and Japanese clothing and accessories were particularly fashionable. In European art, this trend was known as *Japonaiserie.* True, the sophisticated sensitivity of Oriental art was a total contrast to that rough-and-ready robustness which was valued in the West for its supposed primitiveness. Both visual worlds were novel, however, and their freshness could be enlisted to revitalize European artistic expression. Gauguin was not alone in thinking along these lines.

The programmatic painting *Vision after the Sermon (Jacob wrestling with the Angel)* (p. 21) is an excellent example of his ability to accommodate Oriental and primitivist visual modes within a single work. Undoubtedly the most ambitious of all Gauguin's paintings, it is in part symbolic of his struggle for recognition, and of his failure to achieve it. We see two groups of figures, separated diagonally down the middle (in the manner of Japanese woodcuts) by a huge tree trunk.

Still Life with Three Puppies, 1888
Oil on wood, 91.8 × 62.6 cm
Museum of Modern Art, New York

18

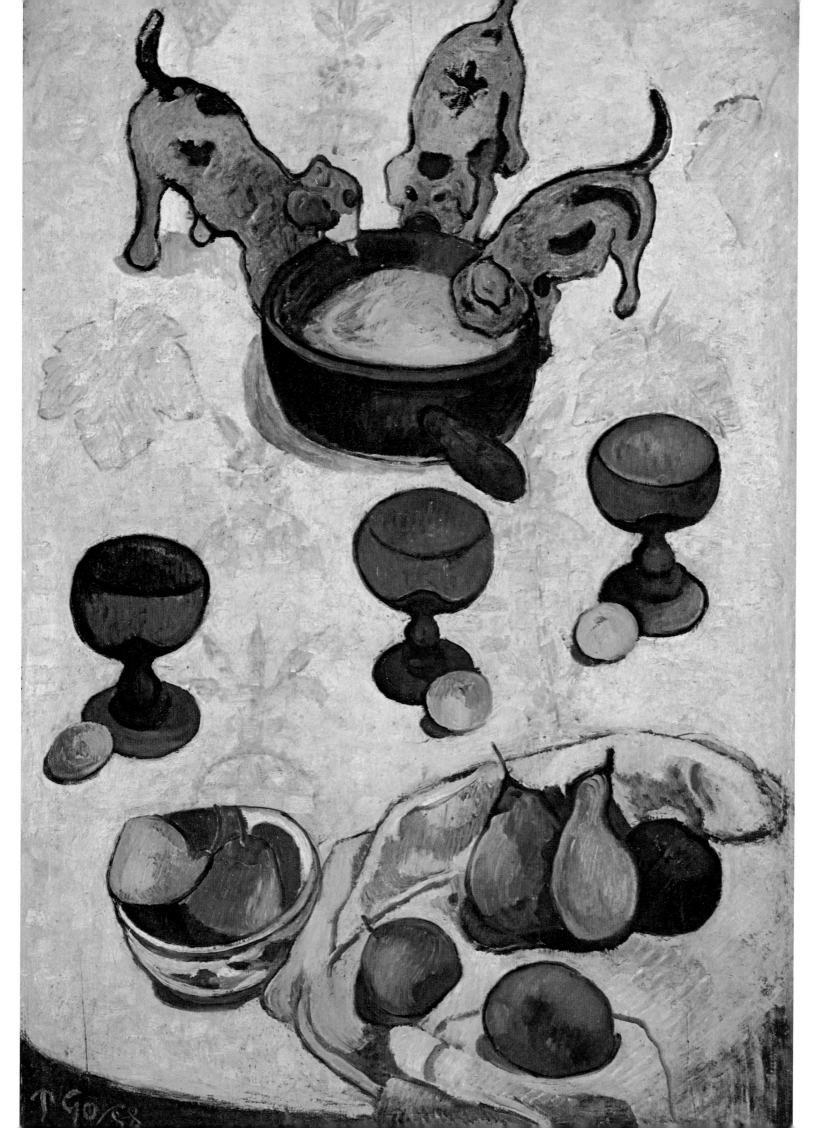

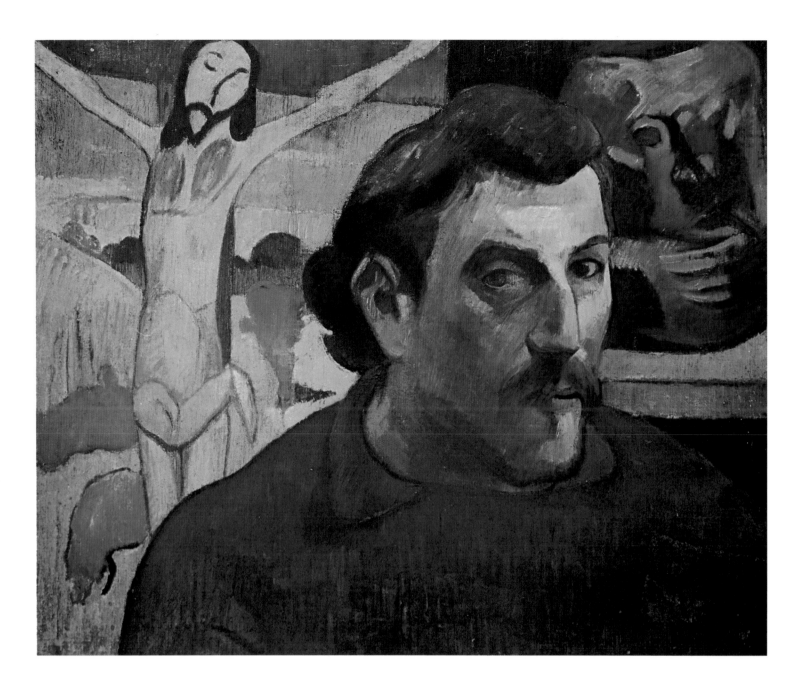

Self-Portrait with Yellow Christ, 1889
Oil on canvas, 38 × 46 cm
Maurice Denis family collection,
Saint-Germain-en-Laye

Dominating the foreground, and almost obstructing our view of the rest, is a group of women in traditional Breton costume, reverently meditating on the sermon they have been listening to. In the background, though, we see an angel with wings outstretched locked in combat with the Biblical figure of Jacob. Gauguin combines an everyday scene of women leaving church with a supernatural scene which exists only in the realm of faith, and in doing so he is also combining two different pictorial traditions. The tranquil and rough-hewn style of folk art has influenced the large figures in the foreground, while the dramatic struggle in the background draws on traditions in Christian art. A third element is provided by the tree, with its axis function reminiscent of Oriental art. The painting makes a direct appeal to a world beyond the senses, and in doing so has recourse to singularly apt artistic means: hard and contrasting colours, a perspective that draws us deeply into the background, together with a powerful emphasis on the foreground, and large, compact areas of colour that only suggest the figures. These artistic means do not represent

things as they are so much as evoke a particular mood. Gauguin was trying to show a vision, but at the same time his painting aims quite simply to *be* a vision.

This painting (at the very latest) established Gauguin as the presiding spririt of the Pont-Aven painters' colony. The group included Paul Sérusier, Laval, Louis Anquetin, Armand Seguin, Jacob Meyer de Haan and of course Emile Bernard. The muse who inspired them was Emile's sister Madeleine, Laval's fiancée. Gauguin kept up a lively correspondence with her, which must have become rather too intense, since Madeleine's parents finally urged her to break it off. Gauguin still had a portrait to remember her by (p. 16), which he had painted in 1888.

Another painter had quit Paris at the same time as Gauguin: Vincent van Gogh. He had headed south, to Arles in Provence, where the shimmering light and the sunlit natural world provided him with inspiration for his work. Van Gogh had already had quite enough of the bare simplicity Gauguin sought in Brittany, in his own Dutch childhood. The two artists shared not only their escape into the provinces but also their plans to found an artists' colony. Gauguin's work alongside his fellow-artists had given him a new self-confidence; van Gogh, on the

Vision after the Sermon:
Jacob Wrestling with the Angel, 1888
Oil on canvas, 73 × 92 cm
National Gallery of Scotland, Edinburgh

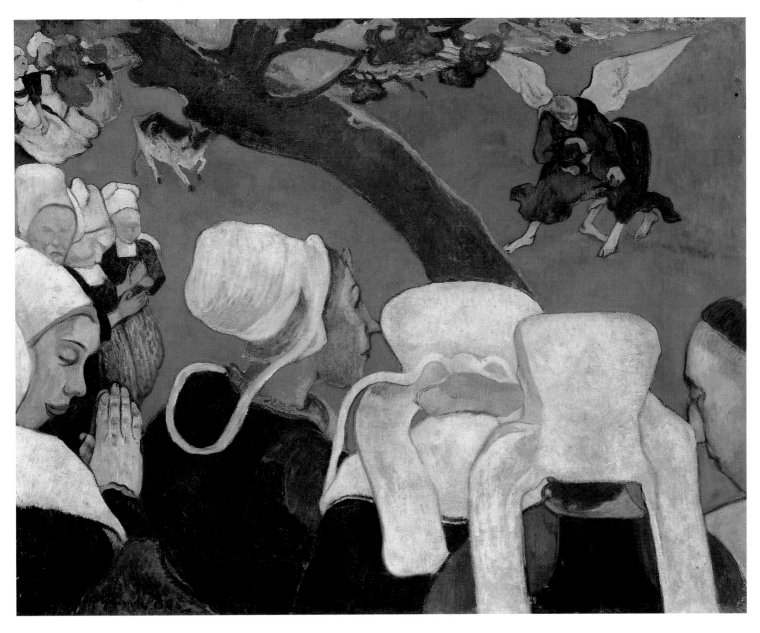

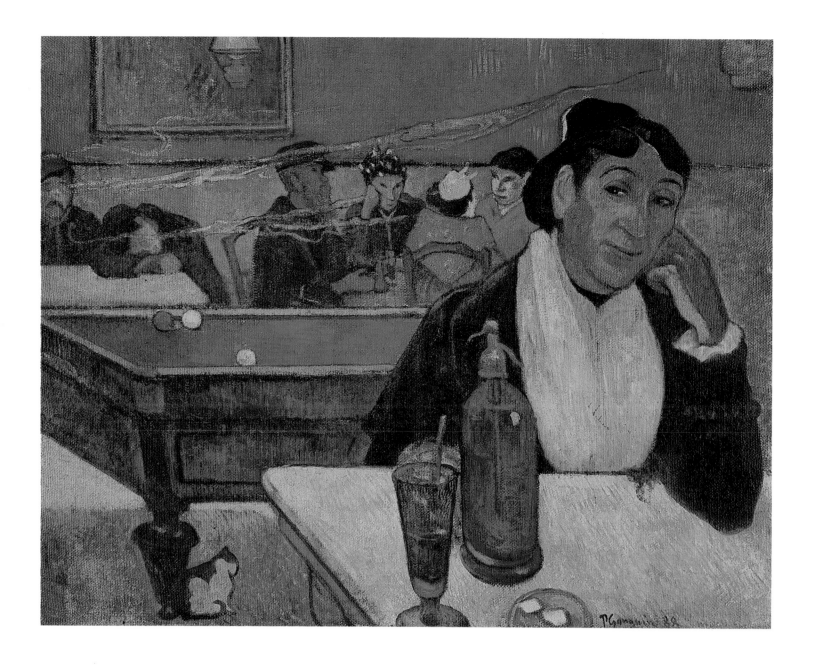

Night Café at Arles, 1888
Oil on canvas, 73 × 92 cm
Pushkin Museum, Moscow

other hand, had hitherto remained alone, and now had plans for the two loners to work together for a few months. His brother Theo, who represented both van Gogh and Gauguin in his capacity as a Montmartre art dealer in Paris, was to see to the arrangements. Weeks in advance, Vincent was already beside himself with excitement. He renovated and prettified his "yellow house" so that Gauguin would have everything he required. Gauguin, however, repeatedly delayed his arrival in Provence, apparently suspecting his dealer of a business ruse: "Theo likes me, but still he wouldn't agree to support me in the Midi just because I have a pretty face. He is a cool Dutchman, he has worked out what's what, and he is out to get the best, exclusive deal out of it."

As always, though, Gauguin was in debt. Theo came to the financial rescue one more time; and then there was nothing for it, and on 23 October 1888 Gauguin joined van Gogh at Arles. Two months of fighting and quarrelling ensued, during which each painter jealously tried to establish the superiority of his own work. Van Gogh had had a high opinion of his fellow-artist: "Everything he does is tender, moving,

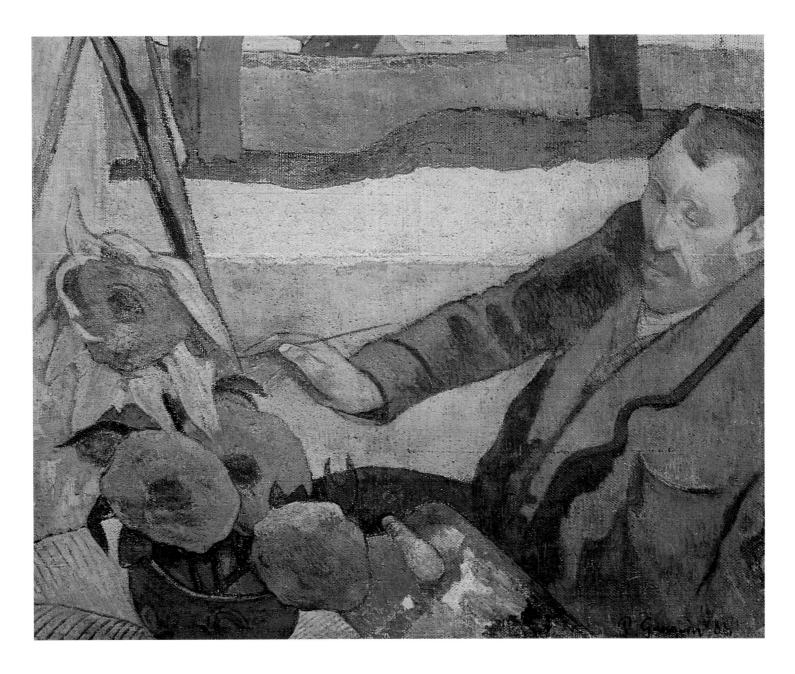

Van Gogh painting Sunflowers, 1888
Oil on canvas, 73 × 91 cm
Rijksmuseum Vincent van Gogh, Amsterdam

astonishing. People do not understand him yet, and he is suffering from his inability to sell — like other true poetic spirits." Their differences, however, grew increasingly obvious. "He is a Romantic," noted Gauguin irritably, "whereas my preferences lie with primitive art. When he applies paint he loves the chance effects of impasto, but I for my part detest disorderly workmanship." Gauguin had hoped to find a keen pupil to boss around. In fact, both had travelled too far along their respective ways as painters to achieve any deeper mutual understanding.

During their period together, van Gogh and Gauguin worked on the same subjects in a spirit of competition. Each would try his hand at the other's works, as a kind of test. *Night Café at Arles* (p. 22) shows Gauguin interpreting one of van Gogh's paintings — or, to be exact, two: *The All-Night Café* and the portrait of its owner, Madame Ginoux. The combination highlights Gauguin's knack of juxtaposing different motifs. The impression of desolate and overwhelming loneliness which made van Gogh's version of the café inimitably his own has disappeared from Gauguin's treatment. Van Gogh had seen the iso-

23

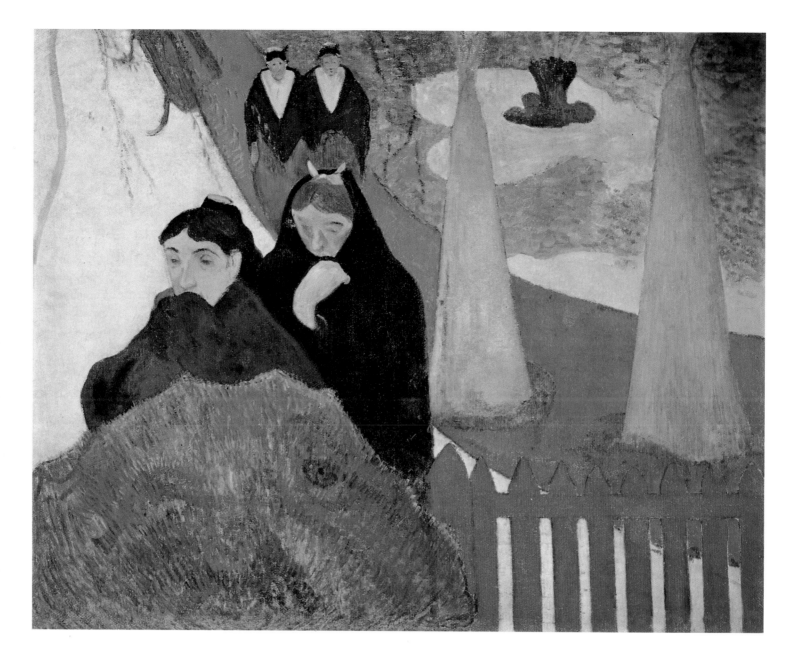

Women from Arles in the Public Garden, the Mistral, 1888
Oil on canvas, 72 × 93 cm
Art Institute of Chicago, Chicago

lated and nameless customers huddled in the corners as his true subject, but Gauguin banishes them to the background, behind the proprietress. She is presented gazing out of the picture, in a manner that eases contact and relieves that oppressive sense of isolation with which van Gogh had invested the café. Gauguin's attention was not on the darker aspects of life, and he preferred to pursue the lighter sides of the imagination.

He had seen van Gogh as a Romantic and himself as a primitivist, and it was certainly true that Vincent's art was as impetuous and vehement as the man himself. Van Gogh was in all things a man of feeling, passionately devoted to an art of expressive intensity. His impulsive will refused to pause before the fearful abysses in the soul of man. Gauguin's involvement with the human condition was marked by distance (comparatively speaking). His watchwords were happiness and harmony, and he arrived at them not through any struggle within himself but by yielding to the alien promises of edenic worlds. Gauguin's art was an art of suggestion, vividly conjuring up realms of alternative realities which lay beyond his ken. Van Gogh's was a more

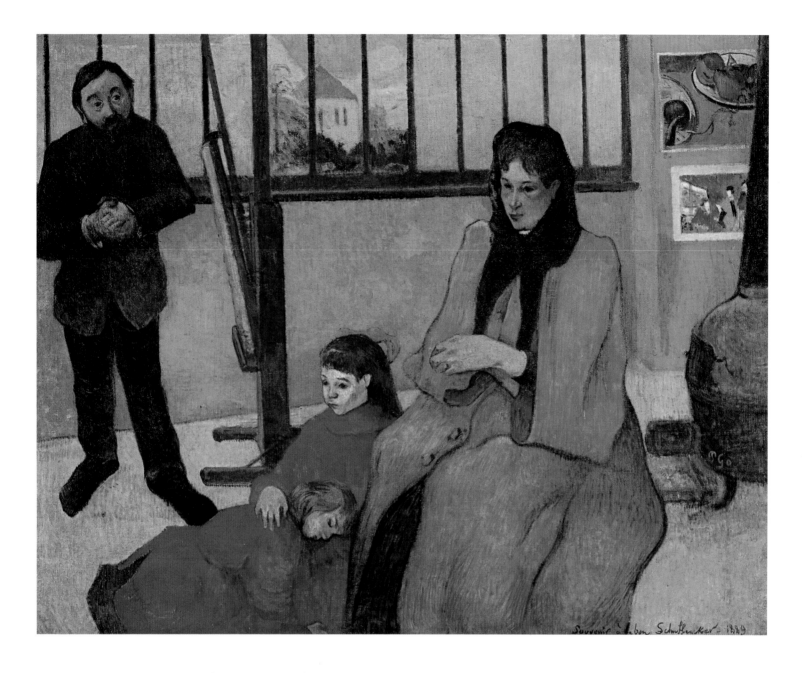

The Schuffenecker Family, 1889
Oil on canvas, 73 × 92 cm
Musée d'Orsay, Paris

introspective art, an art of expression that was centred on his own personality and problems.

The break was not long in coming. "Ever since I had decided I wanted to leave Arles," wrote Gauguin, "he had been behaving so oddly that I scarcely dared breathe. 'You want to go,' he said, and when I replied 'Yes' he tore off a strip of newspaper bearing the following words and handed it to me: 'The murderer has fled.'" For van Gogh, it meant the collapse of his hopes for relaxed work with fellow-artists in the southern sun. At night he would often get up and creep into Gauguin's room to reassure himself that the other was still there. It was only Vincent's illness that still kept Gauguin in Arles: "Though we are at odds on some things, I cannot be angry at a good fellow who is sick and suffering and needs me."

On 23 December, exactly two months after Gauguin's arrival, the state of affairs grew dramatically worse. Gauguin went out for an evening stroll, and Vincent, forever suspicious, followed him. Gauguin heard his familiar footfall, turned, gazed into van Gogh's distraught face, and supposedly saw an open razor in his hand. Vincent instantly

25

The Yellow Christ, 1889
Study for the painting in Buffalo
Watercolour, 15.2 × 12.1 cm
Chapman collection, New York

The Yellow Christ, 1889
Oil on canvas, 92 × 73 cm
Albright-Knox Art Gallery, Buffalo (N.Y.)

turned and ran home, and Gauguin, somewhat disturbed, spent the night in a hotel. Next morning, as he was about to return to the "yellow house", he found the whole of Arles in an uproar: once he was at home, Vincent, tormented by hallucinations and pain, had cut off his left ear-lobe, with the very razor Gauguin claimed to have seen him carrying. After he had stanched the flow of blood, van Gogh had wrapped the severed lobe in a handkerchief and hurried to the town brothel, where he gave it to one of the prostitutes. He then walked home and went to bed as if nothing had happened. And there the police found him when they were alerted early in the morning. He was taken to hospital.

At the time, Gauguin had just completed *Van Gogh Painting Sunflowers* (p. 23). In his fellow-painter's portrayal, van Gogh has a wild look and his brush arm is stretched out awkwardly. Gauguin was trying to capture that manic compulsion which drove van Gogh to paint, and the way his paintings seemed almost to make themselves. "It really is me," van Gogh commented, "though it looks as if I had gone mad." And in fact the Gauguin affair was the straw that broke the camel's back: van Gogh became profoundly sick, and his time with Gauguin was his last at total liberty. The brief spell that remained to van Gogh in his short life was mostly to be spent in confinement. Gauguin, meanwhile, left Arles the same morning, without seeing the other artist again. His prompt retreat looked distinctly shamefaced; though later, in his book *Avant et après,* Gauguin justified his conduct by claiming Vincent had threatened him with the razor. At all events, the episode was not inconveniently timed from Gauguin's point of view: now no one stood between him and the wide world any more. The van Gogh adventure nicely exemplifies a certain man-of-the-world wiliness that constantly accompanied Gauguin's artistic endeavours. He was always capable of keeping his distance. Gauguin too saw the unison of art and life as his goal; but van Gogh's attempt to reach that goal was the more earnest of the two. Gauguin wrote off the time he hed spent in Arles as a bad experience and as a strategic concession to his dealer, Theo van Gogh.

Gauguin began 1889 in Paris. He had fled to this old friend Schuffenecker — "le bon Schuff", as he affectionately called him — who had taken a job as a drawing teacher after the stock exchange crash. Schuffenecker had abandoned his artistic ambitions for a steady income, and now seemed to be a happy family man. Aptly enough, Gauguin therefore painted his friend in the family circle: indeed, in *The Schuffenecker Family* (p. 25) Claude Emile's wife and children are the central figures. Typically for Gauguin, they are positioned emphatically up front, even cropped by the edge of the picture. Gauguin's friend, on the other hand, is standing discreetly aside by the easel, as if he too intended to paint the mother and children. He is looking at his family with a curious, almost fearful gaze. Schuffenecker's fears may not have been altogether unfounded; at any rate, she and Gauguin are said to have had intimate talks. The composition, with its massively dominant female figure and the timid man in the background, is certainly unusual: the artist has used his

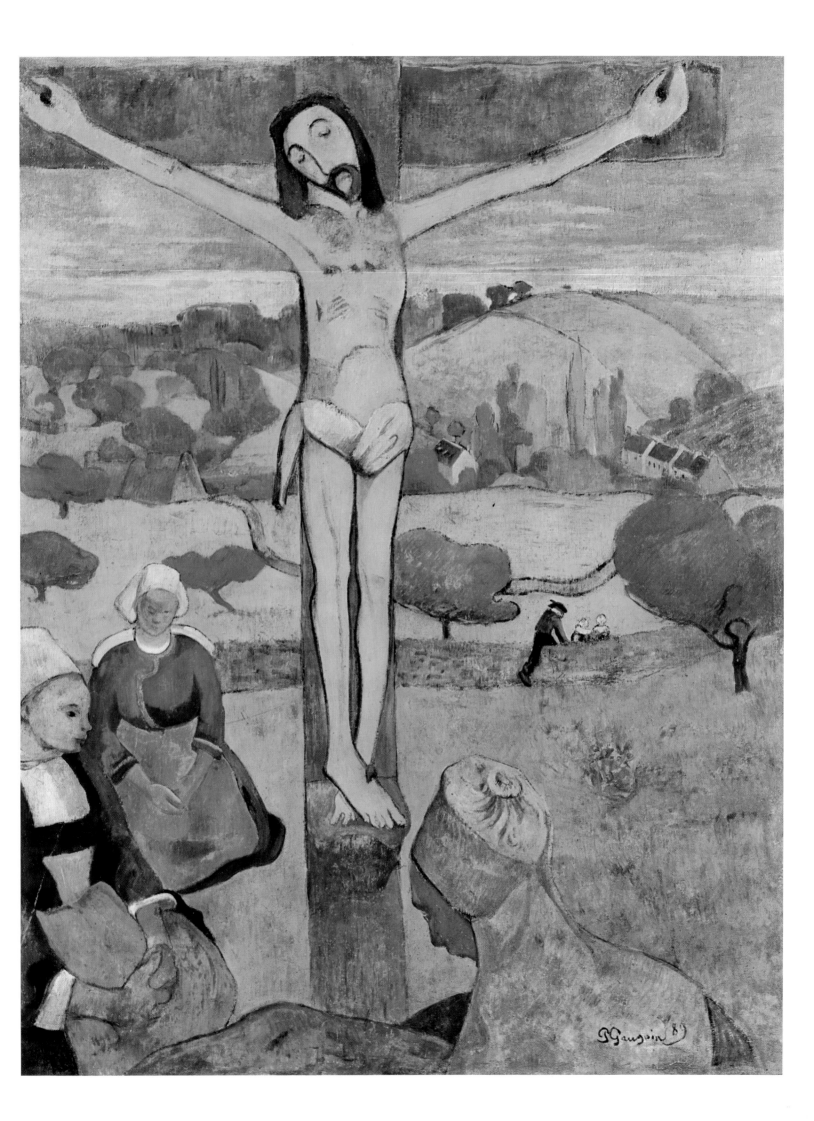

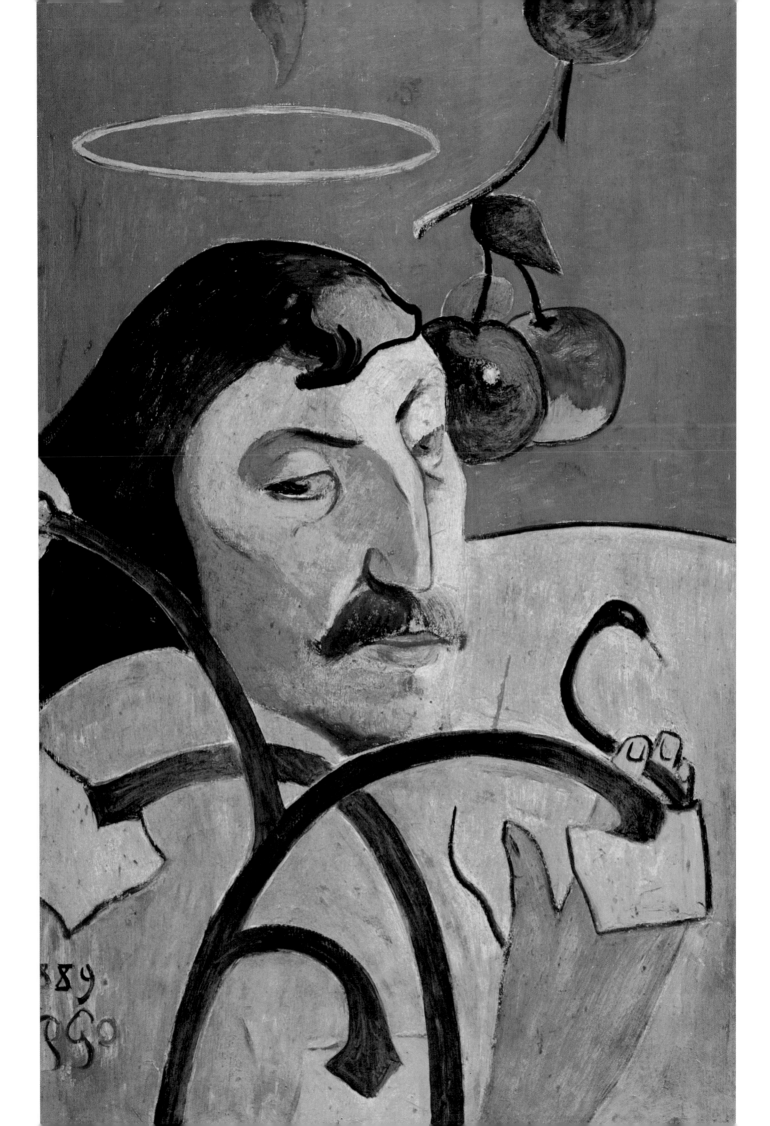

knowledge of the family's life for a quite merciless exposure of the couple's relations.

Schuffenecker's flat remained Gauguin's base for a few months. He exhibited with a group of twenty Brussels artists known as *Les Vingt*, and had high hopes of *Vision after the Sermon,* but he was doomed to disappointment. If one critic, Octave Maus, felt Gauguin's work occasioned "great hilarity", the painter could put it down to the ignorance of the public. It was different, though, when an eminent authority whose own art played an important role in Gauguins' development expressed his contempt. Pissarro wrote: "What I find reprehensible in him is that his synthesis is unrelated to our modern philosophy, which is a social, anti-authoritarian and anti-mystical philosophy. For this reason, the problem is serious. He is taking a step backwards. Gauguin is not a seer. He is simply crafty."

The Yellow Christ (p. 27) makes clear what Pissarro meant. Once again we find Gauguin attempting a vision: a crucifix appearing to women deep in prayer. The starkness of the colours used for the crucified figure and the tops of the trees creates a supernatural mood. The yellow Christ is appearing both to the women (within the painting) and to us (the whole painting is a vision). According to Pissarro's criticism, Gauguin's art must be anti-social, authoritarian, and mystical. It is true that Gauguin paid no attention to considerations of societal progress; quite the contrary, conditions in France were among his reasons for leaving the country. In his art, Gauguin sought refuge and security in a familiar realm of faith and tradition, personal sympathy and individual freedom. The slogans of Impressionism resembled the period's middle-class ideals in stressing dynamic change and progress. Such notions had no place in Gauguin's pursuit of the supernatural.

The monumental crucifix had already figured in the background of *Self-Portrait with Yellow Christ* (p. 20). It was a cross Gauguin had seen in the village church at Tremalo, near Pont-Aven. As an image of simple belief, and as a folk artefact, it fitted into Gauguin's visual world very well. And as an element in his self-portrait it implies parallels between artistic creativity and the Creation. Furthermore, the image of God dying in human form suggests in turn that the artist suffers. Gauguin's expression in the picture is one of acute self-centredness that hardly seems to accord with thoughts of suffering and piety. For Gauguin, though, the role of the artist always remained just that: a role. And best of all he liked to put on the mask of the solitary, suffering seer whose creative powers were ignorantly despised.

We see him in that mood in his *Caricature Self-Portrait* (p. 28). His arrogant air has been replaced by one of despondency and dejection, so that the artist appears before us as a melancholic. Ever since the Renaissance, melancholy had been considered a hallmark of creative people, who were seen as suffering not for any particular reason but because of the general condition of the world, which obliged the artist to practice renunciation. Gauguin looks so infatuated with himself in this work that we might interpret it as an unintentional caricature, if it were not for the wavy ornamentation which threatens to engulf the

LEFT
Caricature Self-Portrait, 1889
Oil on wood, 79.2 × 51.3 cm
National Gallery of Art, Washington

PAGE 30
**Portrait of a Woman
with Cézanne Still-Life, 1890**
Oil on canvas, 65 × 55 cm
Art Institute of Chicago, Chicago

PAGE 31
Ondine, 1889
Oil on canvas, 92 × 72 cm
Cleveland Museum of Art, Cleveland

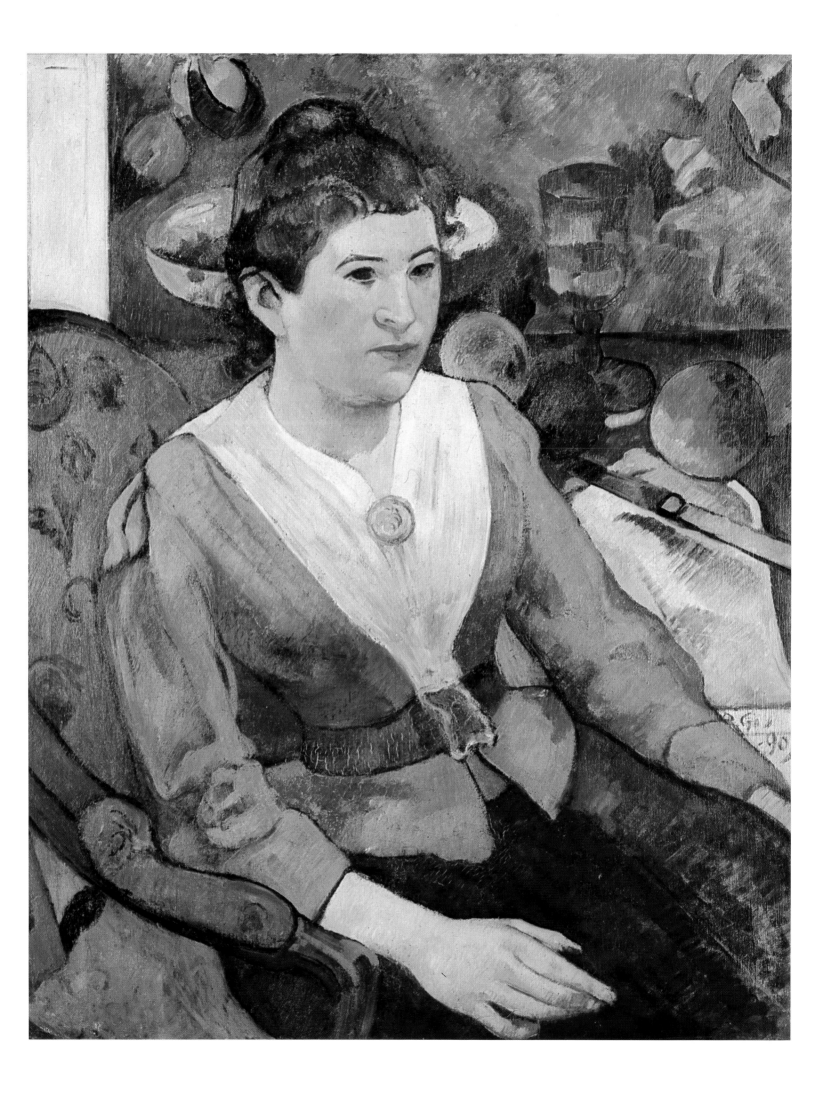

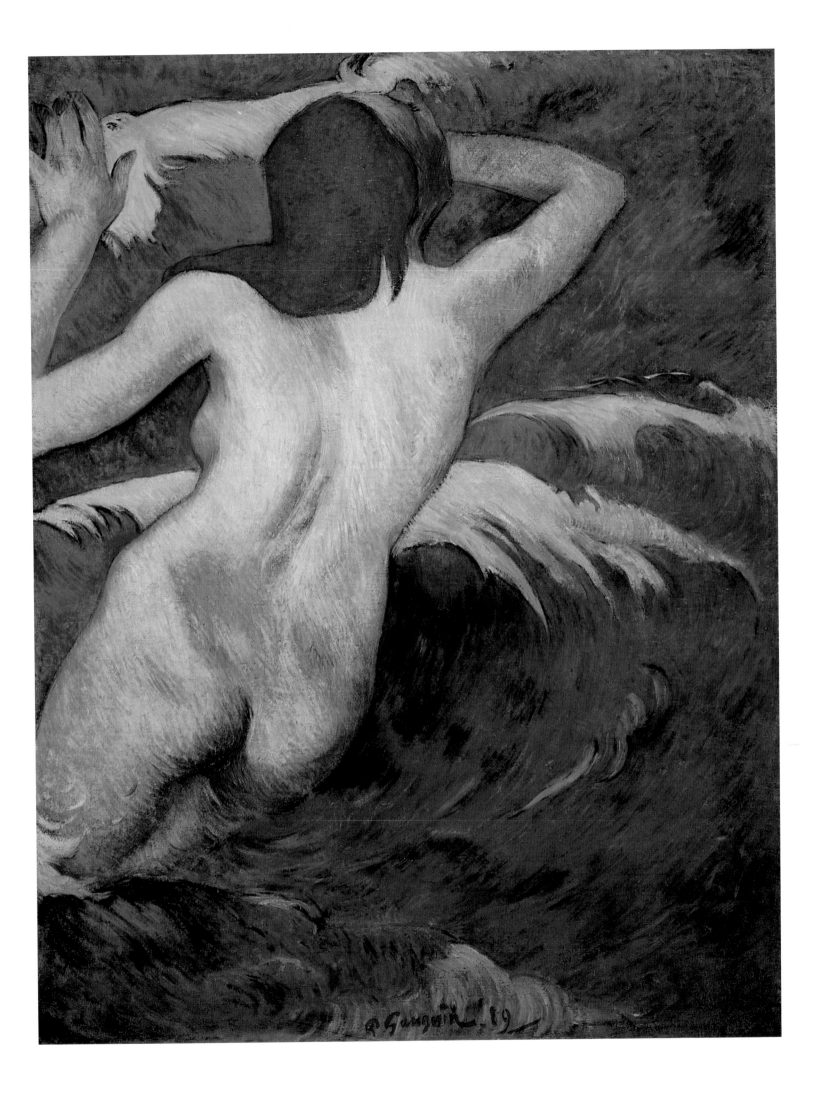

artist's head at the centre. There is no sense of spatial dimensions in the free flow of colours in the background. Three Christian symbols — the apple, the halo and the snake — bridge the gap between representation and abstraction; and it is their association of sin and redemption which those symbols conjure up which make us see Gauguin's painting with greater sympathy. What emerges from the combination of a seemingly unambiguous expression of woe and decorative elements apparently devoid of meaning is an evocative portrayal of the enigmatic character of the artist.

In the years 1888 to 1891, Gauguin was wholly under the influence of an artistic circle whose avowed aims were to be more inventive, more individual, and quite simply more *different,* than anyone else. They were dandies who liked to stroll about the streets of Paris eccentrically and strikingly dressed, revelling in the feeling of being outsiders. Writers such as Stéphane Mallarmé and Paul Verlaine were the heart of this circle, and Gauguin belonged to it too. Every Tuesday evening there was a *soirée* at Mallarmé's where the latest fashions were discussed and plans were made to capture the public limelight with further sensations. Jean Moréas had published the Symbolist

Fair Harvest, 1889
Oil on canvas, 73 × 92 cm
Musée d'Orsay, Paris

Manifesto in 1886, and that had given the clique its name: the Symbolists. They aired their views in the *Mercure de France,* which published Albert Aurier, the only critic to have taken note of van Gogh during his lifetime. What linked these individualists was their somewhat forced pose of being ahead of their time; affinities united them, however they might disagree on current affairs. In due course, protesting against the movement's obsession with grandeur, Gauguin observed that Symbolism was "no more than another name for a deficient response to life". Still, his paintings of the period demand the same sensitive empathy as Symbolism, irrespective of theoretical notions. And his visionary works require the public to be in tune with him, and prepared to accept the suggestiveness of different and profounder worlds. If we do not grasp his art instantly, we never shall.

Emile Aurier's essay 'Gauguin, or The Symbolist Movement in Painting' was the circle's farewell present when Gauguin departed for the tropics for the second time. It appeared in the March 1891 issue of *Mercure de France* and — ironically enough — used Gauguin's work in order to illustrate the programmatic tenets of Symbolism. Aurier declared that a work of art must possess five characteristics in order to the Symbolist, characteristics which Gauguin's paintings naturally had.

Mimi and her Cat, 1890
Gouache on cardboard, 17.6 × 16 cm
Private collection

(1) "A work of art must be ideative, because its sole ideal must be the expression of an idea." (2) "A work of art must be symbolic, because it gives formal expression to an idea." (3) "A work of art must be synthetic, because it records its forms and signs within a general system of meaning." (4) "A work of art must be subjective, because the object is never viewed *qua* object but as a sign perceived by the subject." (5) "A work of art must be decorative, because — in the true sense of the word — decorative art as understood by the Egyptians and in all probability by the Greeks and primitive peoples too was nothing other than an artistic revelation which was at once subjective, synthetic, symbolic and ideative."

This timely statement gave Gauguin the theoretical support he needed: his art, it seemed, was primitive in the best of senses. Confirmed in his position, he presently felt able to set off in quest of immediate primitive experience in the South Seas.

In a work such as *Ondine* (p. 31) we see Gauguin getting his own back. This woman, who belongs so entirely to the element she personifies, and thus programmatically foregrounds that essential naturalness which the Symbolists insisted is innate to women, could only have been painted by the Gauguin of about 1890. The human figure and the waves merge in a highly artificial, contrived manner which draws upon literary models and stands in direct contradiction to Gauguin's avowed aim of simplicity. The image is no more than an illustration of a story the artist had read. And reading a book, after all, is a quite different business from contemplating the tranquillity of rural life.

But Gauguin still had not a centime for the travels he felt were so urgent. Friends and fellow-artists organized a wholesale auction at the Hôtel Drouot in Paris. One reason they were so eager to help may have been that they were feeling pangs of conscience: at one time or another they had all agreed to accompany Gauguin to Tahiti, only to decide they preferred life in the big city to peaceful boredom in thatched huts beneath a tropical sun. Thirty canvases were offered for sale at the auction. Eighteen months before, at the great Impressionist and Symbolist exhibition in the Café Volpini, Gauguin had failed to sell a single one of the seventeen works he put on show. This time he found purchasers for no fewer than twenty-nine.

Among them was Edgar Degas. He bought *La Belle Angèle (Portrait of Madame Satre)* (p. 35) for 450 francs. Doubtless it was not mere chance that led him to choose this picture, combining as it does all Gauguin's principal and characteristic motifs of the past three years: the rustic features of the girl in her Breton costume, with the primitive cult figure posed beside her like an accessory. Both motifs are related to a background of decorative detail; spatial considerations are replaced by a juxtaposition of areas which mark out each motif's territory, so to speak.

The financial success of the auction boosted Gauguin's self-confidence, and in March 1891 he journeyed to Copenhagen. He was hoping, as he wrote to his wife, "to embrace my children without being told by you or your family that I am a worthless individual." The reunion

La Belle Angèle (Portrait of Madame Satre), 1889
Oil on canvas, 92 × 73 cm
Musée d'Orsay, Paris

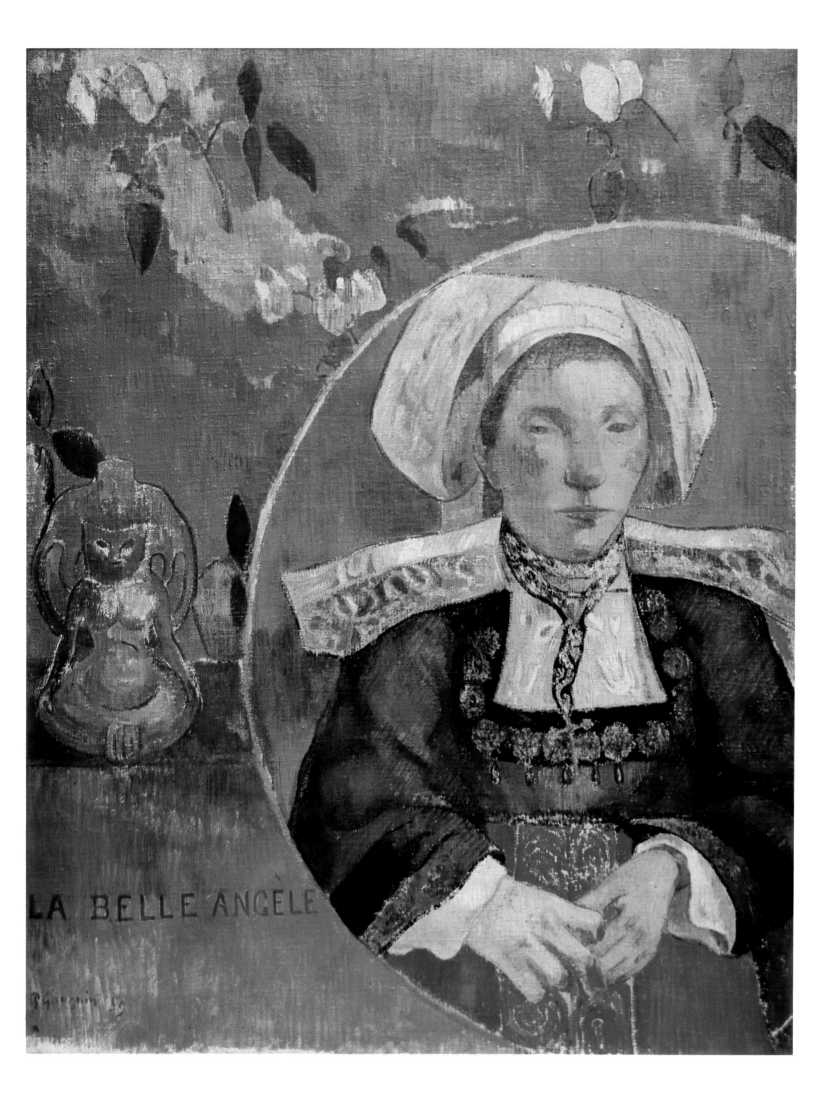

LA BELLE ANGÈLE

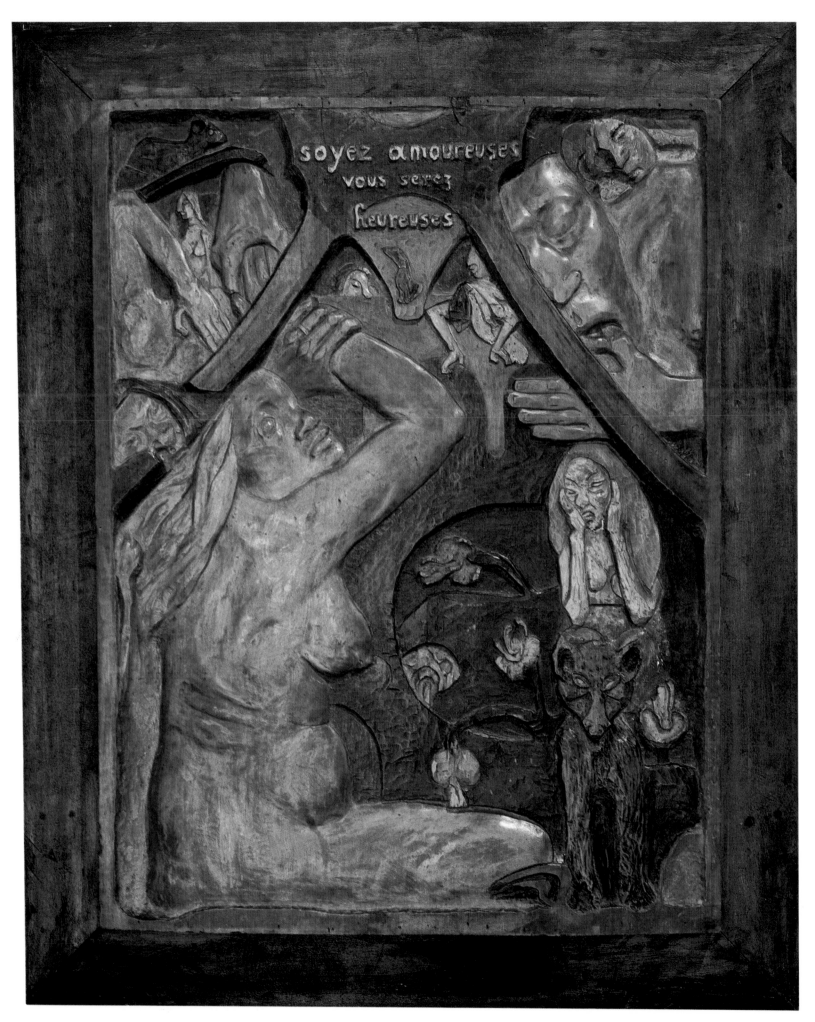

re-awakened hopes of family happiness in him, and after his return he wrote in emphatic tones to Mette: "I assure you that in the next three years I shall win my battle, so that we — you and I — will be able to live safe from troubles and cares . . . Farewell, dear Mette, dear children. Keep me in your hearts. And when I come back we shall marry anew." Plainly Gauguin saw his art as a mission, a task which he had to perform and for the sake of which he had to forego domestic happiness. Viewed like this, his move to the South Seas appears to have been made less in hope of a life of bliss than with a sense of needing purification. Gauguin's conception of art had always included a reverent feeling that piety and faith were essentials in life; now, as he wrote his letter of parting, art itself acquired a religious dimension.

A grand farewell buffet was organized at the Café Voltaire, a favourite rendezvous. Mallarmé, as master of ceremonies, drank a toast to Gauguin's future return. People drank, acted, and read out poems. Gauguin is reported to have been very depressed; he was seen weeping, and staring blankly into nowhere. Nevertheless, on 4 April 1891 Gauguin left Paris by the night train. He was bound for faraway Tahiti.

Study for La Perte de Pucelage (The Loss of Virginity), ca 1890/91
Chalk, 31.3 × 32.5 cm
Block collection, Chicago

Be in Love and You Will Be Happy (Soyez amoureuses vous serez heureuses), 1889
Carved, polished and polychromed linden wood, 95 × 75 cm
Museum of Fine Arts, Boston

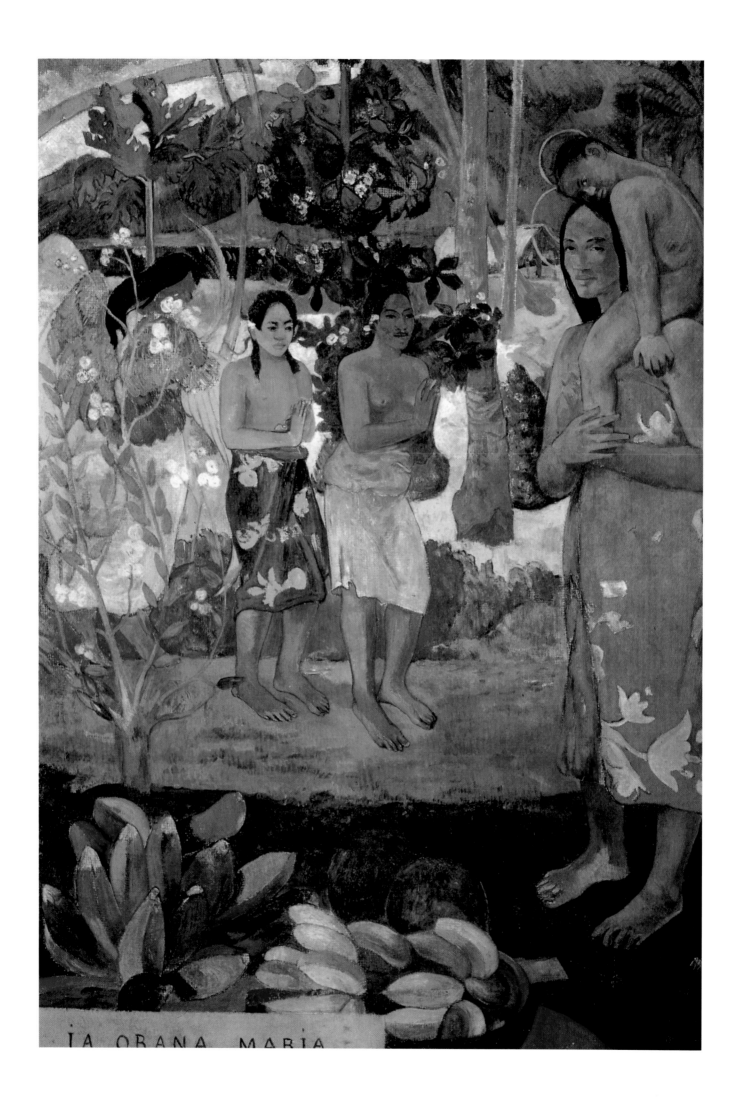

Tahiti : A Studio in the Tropics
1891 – 1893

Tahiti was no longer quite as paradisiac as the stage-set magic of the world fair had promised. Discovered in 1767, the Pacific island was now a mere colony, where French officials and soldiers strutted about as self-importantly as they did back home. And Gauguin's repeated and enthusiastic insistence on primitivism paled a little once he was on the spot. The painter, seen as a kind of ambassador from the homeland, was given an official reception at the harbour; and in his pocket he had a letter of recommendation, doubtless intended to make his alien environment more bearable. The governor himself turned out, and ceremonially welcomed the rebel – who affected to be enduring society's contempt with heroic patience. The nature of his arrival exposes the character of Gauguin's South Seas adventure: he went as a colonist. Not, it is true, as a colonist bent on political subjugation, but as one who wanted to take from the local culture whatever he felt could be of use in the Old World.

"We're wasting our time here," whined the critic Charles Morice, shivering in a wintry Paris and daydreaming of the adventurous Gauguin. Paul Signac, who doubted the artistic value of the journey from the outset, was more sceptical: "A man who paints black in the North and blue in the South is a buffoon." Of course the Symbolist belief in the all-powerful supremacy of the imagination was certain to provoke questions concerning Gauguin's aims; after all, anyone with the necessary imagination hardly needed to travel halfway round the world to instil new verve into his art.

Gauguin was aware of the dangers. But his wish to find out about the Polynesian peoples and their culture, and to get to know them as wholly and informally as his European background and education permitted, was genuine – and he leapt in at the deep end. His letters home show how good his intentions were: "It was like decay and blossoming, law and fidelity, artificiality and naturalness – there was the evil one, breathing her impurity and lies and wickedness over the good woman," he wrote, contrasting the wife of a French gendarme with a local beauty. He hadn't a good word for Europe any more; and by the same token his rosy view of the tropics was coloured by his dreams and preconceptions.

At the bottom left of the painting of that name (p. 38) we see the words, 'Ia Orana Maria' in Roman characters. The words mean "Hail

The God Taaroa and One of His Wives, 1892/93
Watercolour, 21.5 × 17 cm
Département des Arts graphiques,
Musée National du Louvre, Paris

LEFT
Ia Orana Maria (Hail Mary), 1891
Oil on canvas, 113.7 × 87.6 cm
Metropolitan Museum of Art, New York

PAGE 40
**Woman with a Flower
(Vahine No Te Tiare), 1891**
Oil on canvas, 70 × 46 cm
Ny Carlsberg Glyptotek, Copenhagen

PAGE 41
Brooding Woman (Te Faaturuma), 1891
Oil on canvas, 91.2 × 68.7 cm
Worcester Art Museum, Worcester
(Mass.)

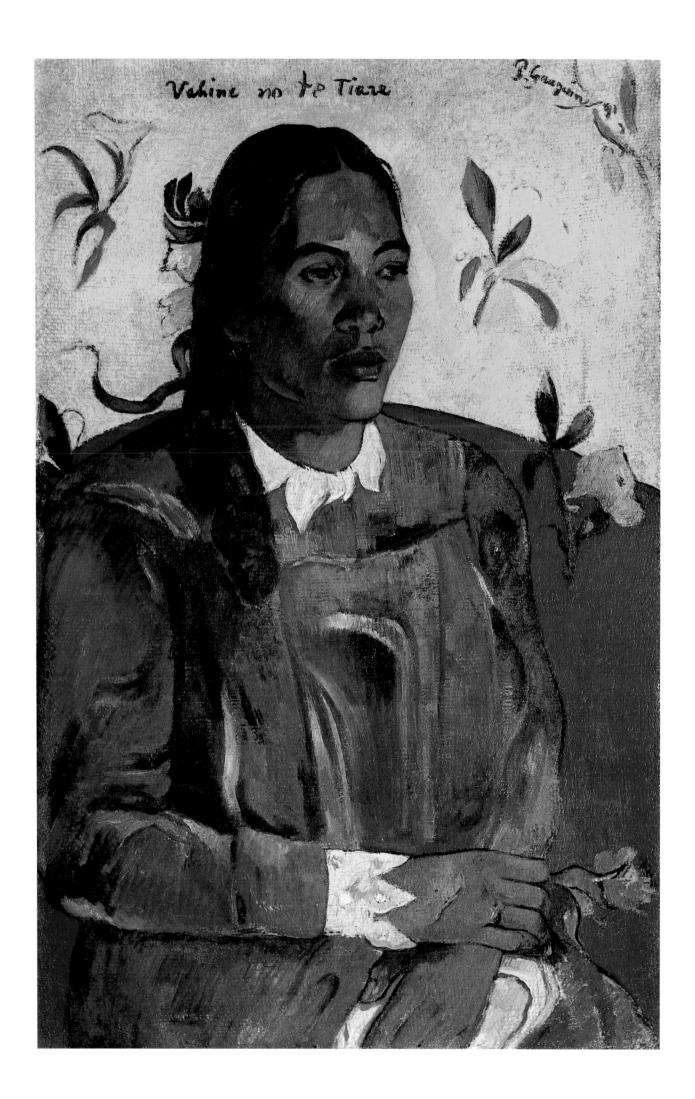

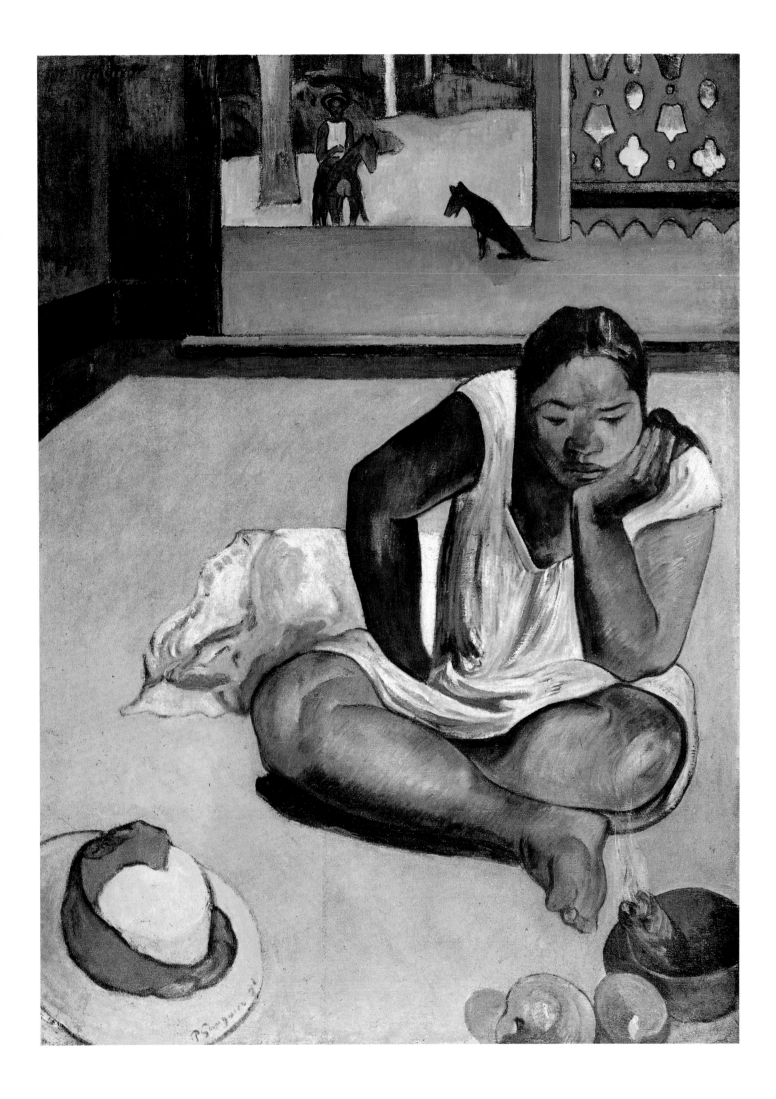

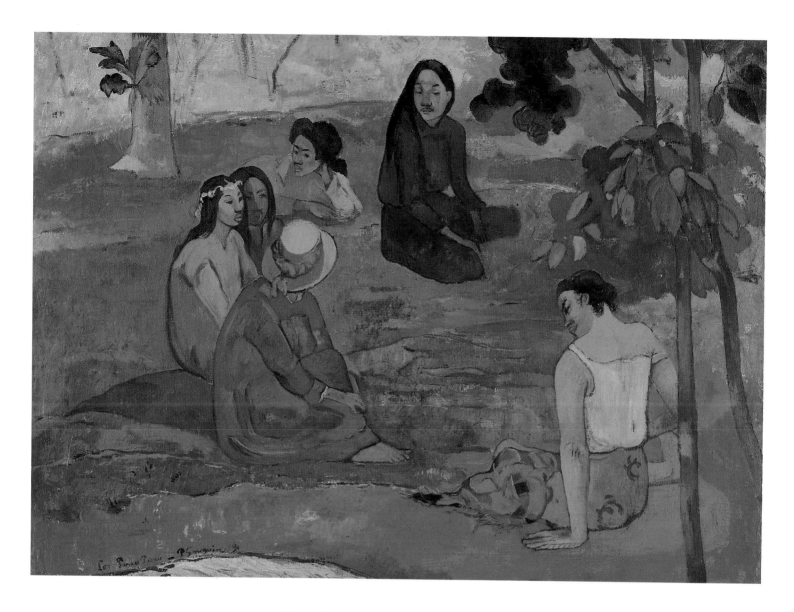

Les Parau Parau, 1891
Oil on canvas, 62 × 92 cm
Hermitage, Leningrad

Mary" and, like the lettering, the subject of the picture returns us to Europe. Gauguin transposes the Christian story of the Son of God to a South Seas setting; and, like Christian missionaries who took for granted that foreign peoples would give them an enthusiastic welcome, the painter places his own religion in the foreground. Everyone in this Nativity, the mother and child and the women approaching to worship, is Polynesian. Part-concealed in the greenery, though, there is also an angel, as if in wait, with the same golden wings as the angel in *Vision after the Sermon*. The setting may be more colourful, decorative and various, but the principle of mixing the everyday and the supernatural has survived from Gauguin's Brittany days.

The folk piety of the Pont-Aven pictures stands revealed as implicitly political in the new work. The local people had not been spared the colonizers' Christian evangelizing, and their own gods were now at odds with the Christian God. He described a young woman named Tehura in these terms: "I do not really know how she reconciles Jesus and Taaroa in her belief. I suspect she worships both." He saw this as one of the islanders' many miraculous talents, an intuitive ability to reconcile opposites. It was an ability he was himself questing for, and which he therefore assumed the local people possessed; but he missed the yawning gap that had opened up between traditional and

imposed beliefs. He had wanted to hold a mirror up to his own world, and that meant that his paintings had to testify to that better world he was convinced he would find in the South Seas. Almost everything he wrote about daily life on Tahiti smacked of the utopian. Those negative traits without which life is in fact lifeless were largely eliminated from his paintings.

Gauguin later recorded his memories of the first Tahiti stay in his book *Noa Noa.* The title is the native name for the island and means "scented land". Gauguin writes of fantastic beauty and tranquillity; but *Noa Noa,* of course, was written for a European audience. It was published in instalments beginning in 1897, and was calculated to excite middle-class readers' longing for exotic parts. It is thus difficult to tell how Gauguin genuinely felt at the time. He presented the island as a paradise, and his paintings and letters from Tahiti conjured up a dream landscape — yet always in contrast with civilized France, of course, which Gauguin affected to despise. His very wish to create art was a product of that civilization. And it certainly did not occur to Gauguin to abandon that wish.

Some thirty miles from Papeete, the Tahitian capital, Gauguin set up house in a bamboo hut in the jungle district of Mataeia. Tehura, a Polynesian beauty, became his live-in lover, and he told her mischievous tales of his wife, saying he had a photograph of her. The "photo-

What's New? (Parau Api), 1892
Oil on canvas, 67 × 91 cm
Gemäldegalerie Neue Meister, Dresden

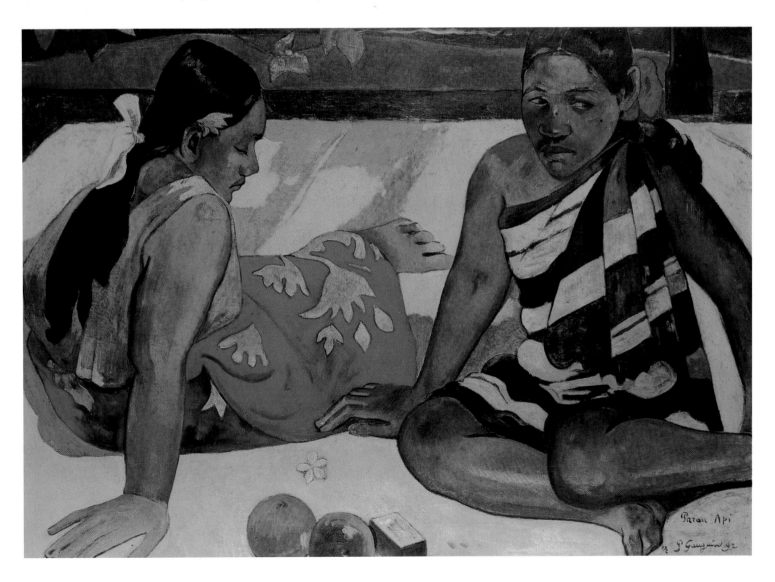

**Two women on the
Beach, 1891**
Oil on canvas,
69 × 91.5 cm
Musée d'Orsay, Paris

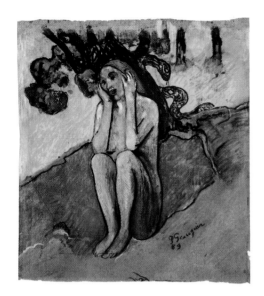

Eve. Don't Listen to the Liar, 1889
Watercolour and pastel,
33.7 × 31.8 cm
Marion Koogler McNay Art Museum,
San Antonio (Texas)

**Woman with a Mango (Vahine No Te Vi),
1892**
Oil on canvas, 72.7 × 44.5 cm
Baltimore Museum of Art, Baltimore

graph" was a reproduction of Manet's scandalous nude *Olympia* (Musée d'Orsay, Paris) which Gauguin had pinned up and which doubled as Mette when he told his stories. With the choice between the innocent nakedness of the native people on the one hand, and civilization's notoriously ambiguous double standards on the other, Gauguin was apparently more likely to find his ideal woman in Manet's nude than in the simple, graceful women of the village.

"Out in the open yet intimate, beneath the shady trees, with women whispering in a mighty palace designed by nature itself," wrote Gauguin in *Noa Noa,* describing the ambience of *Les Parau Parau* (p. 42). We see a group of the local people sitting in a circle, relaxed and talking. Gauguin's approach is still that of the remote outsider, there is nothing *voulu* in the handling of the foreground, and the people merge into the restrained colourfulness of the setting.

The approach is the same in *Brooding Woman (Te Faaturuma)* (p. 41). The Tahitian girl is seen with a new closeness and directness, though we still sense a discrepancy between the model and the picture's format. It is as if Gauguin were painting as an anthropologist, and the details of the hut are included as though for study purposes. The naturalness of the hut, the carvings that adorn the rear wall, and the objects the girl has collected, are all essential components in the portrait — which (as usual) does not tell us the model's name. During his time on Tahiti, Gauguin was not interested in the individuality of his subjects. Still, in the first pictures he painted he was plainly trying to capture the environment which was to become his artistic home.

"In any country I first need a gestation period," wrote Gauguin, describing the problems he encountered in coming to terms artistically with his new life. "I first have to grasp the essence of the plants and trees, of the vast variety of nature, which is so capricious and so copious and refuses to be defined or taken hold of." During his first years on Tahiti he painted relatively few pictures; the new lease of artistic life he had hoped for was slow to materialize. Indeed, even on the island, which seemed so easy-going and delightful, he was plagued by bad moods. "For some time I had been surly and dejected. And my work was suffering. I lacked certain essentials, and it was depressing to find myself powerless to tackle the artistic tasks confronting me. But above all I simply wasn't in the mood."

It was this frame of mind that produced paintings such as *Brooding Woman.* That melancholy which supposedly afflicts the creative had him in its power again — and he projected his own moods onto the Tahitian people, without troubling to ask if it was right to do so. They too (he claimed) had creative powers. Their indolence was part of their view of life, and they did not see work as the most important thing. They lolled drowsily in the sun, immersed in peaceful talk, taking the day as it came. In his portraits of Tahitian beauties, Gauguin was trying to reconcile the graceful idleness of the island people with his own sorrowfulness. But the two approaches to life were radically different.

The best example of his attempt is *Woman with a Flower* (p. 40). The painting uses the same background as the *Caricature Self-portrait,*

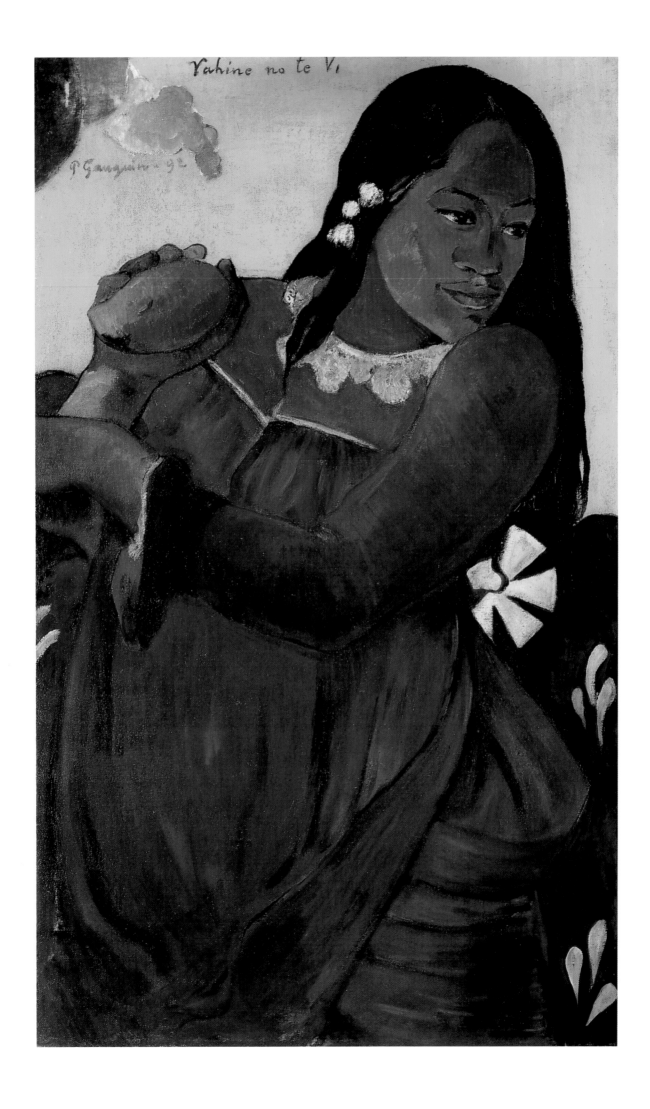

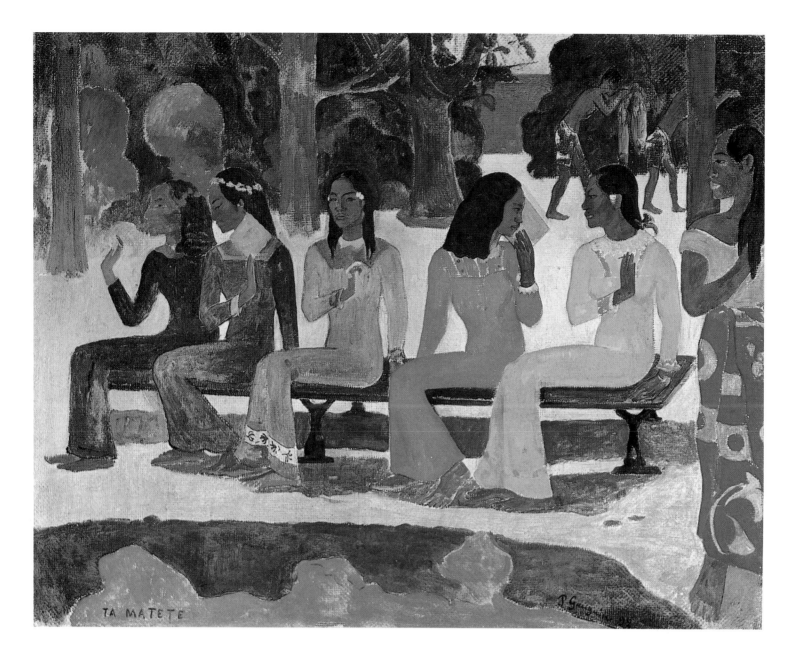

TA MATETE

We Shall Not Go to Market Today (Ta Matete), 1892
Oil on canvas, 73 × 91.5 cm
Kunstmuseum, Basle

but this time the abstract pattern in fact does no more than provide the rearward limit of the picture. The woman portrayed is not hopelessly at the mercy of ornamental colours and lines, but instead sits with a monumental presence. In her right hand she holds a flower, symbolic of growth and fertility. In the self-portrait, the passion flowers echoed Gauguin's own wretchedness and misery; but in the new painting their significance pales before the tranquil charisma of the woman. In the self-portrait, Gauguin's compulsive efforts to establish several levels of meaning had resulted in a bold but tawdry exhibitionism; but in the new painting his respect for the woman's ingenuous dignity is dominant. It is an honest attempt to represent the clash of different cultures, where civilized sophistication meets natural simplicity.

In *Woman with a Mango* (p. 47), Gauguin's sensitivity towards that polarity takes on the form of European classical iconography. Evidently Gauguin had abandoned his wish to appropriate a primitive language to his own use. The physical presence of this woman, carrying her fertility symbol as a saint might carry her attribute, was con-

48

Joyeuseté (Arearea), 1892
Oil on canvas, 75 × 94 cm
Musée d'Orsay, Paris

ceived in the visual terms of a Giotto or Leonardo da Vinci. The decorative detail was kept to a minimum, and the massive figure of the woman filled the canvas without any need for the painter to indulge his talent. It is rare for Gauguin to acknowledge roots in western art so unambiguously; but we see that when he does avail himself of traditional modes his work no longer appears in any way contrived and indeed acquires a dimension of natural inevitability which remains impressive, irrespective of fashions in art.

Gauguin preferred not to name his models; and not only their identities but even their very sex is often unclear. He saw them with a European eye, and people of a different race often looked alike. It was the colonist's typical way of seeing; but in Gauguin there was also that love of reconciling opposites which led him to stylize the Tahitian people as if they were mythical creatures. Hermaphroditism is an ancient notion: even the account of Eve's creation from Adam's rib given in Genesis reflects the myth. In Gauguin's day, the Symbolists had revived the idea. And Paul Gauguin, in his island paradise, had all the time in the world to experience the merging of the sexes, or at

Head of a Woman, ca. 1891/92
Watercolour, 17 × 11 cm
Private collection, New York

least to effect that merging in his dreams and paintings. "With the sensuous animal grace of the androgyne," wrote Gauguin in *Noa Noa,* "he walked before me. It seemed as if the profusion of plantlife all around were embodied in him, vital and alive. Was it a man that walked before me? Was it a childhood friend who attracted by virtue of his simplicity and his complexity? Or was it not rather the forest itself, living, sexless and seductive?"

In these words, everything is unsettled and in flux. Man and woman, child and adult, man and nature merge. The duality of body and soul — always a torment to westerners, and at the root of the new psychoanalysis of Gauguin's day — is conspicuous by its absence. Gauguin felt as if he had penetrated to the core of human nature, and tirelessly he extolled the unspoilt harmony of that imaginary world — which he perceived only from a distance.

Near the Sea (p. 53) is one of his attempts to capture that imaginary world in appropriate imagery. The harmony of mankind and the elements is symbolized most clearly in the positions of the women: the figure in the foreground is slowly stripping, offering herself to the sea, while the second woman is bent over with her arms raised, as if in worship. These attitudes of offering and worship represent a process of unification with nature which has ritual and cultic qualities and indeed seems religious. A quest for that same unification can be seen on Gauguin's part, in his use of elaborate formal decoration and colouring: through his artistic technique, through the sensual colourfulness of abstract patterns, the painter attempted to create a harmony of Man and Nature.

One of the means of creating such a harmony is known as synaesthesia. In painting, synaesthesia relates to the art's proximity to music, dance or drama: an appeal is made not only to the eye but to all the senses, and the rhythms of form and colour are equivalent to the rhythms of sound and movement. The Symbolists, too, had revived this concept of synaesthesia, which had been largely neglected since the Classicist separation of the various artistic genres. A complete work of art should be intoxicatingly staged so as to grip the beholder; Edgar Allan Poe's statement that "the greatest praise we can bestow on a poet is that he seems to be seeing with his ear" might have served as a motto for this kind of aesthetic.

One of Gauguin's most ambitious attempts at putting the principle of synaesthesia into practice was *Joyeuseté (Arearea)* (p. 49). We see two Tahitians of scarcely distinguishable sex, and a dog. Both the human forms and the animal are handled in glowing colours, in such a way as to establish them on the same level of natural, animal existence. The woman playing the flute, and the background figures performing a ritual dance before an idol, call forth associations with music. Gauguin's painting aims to produce a sense of peaceful elation in us, so that we ourselves can imagine we feel the grace of nature and of music which the picture's colourful play of patterns and forms presents. Here too, Gauguin presupposes that we are in sympathy with his views and responses. And only if we are will we be able to feel the nature of the artist's intuitions.

**Her Name is Vairaumati
(Vairaumati têi oa), 1892**
Oil on canvas, 91 × 68 cm
Pushkin Museum, Moscow

50

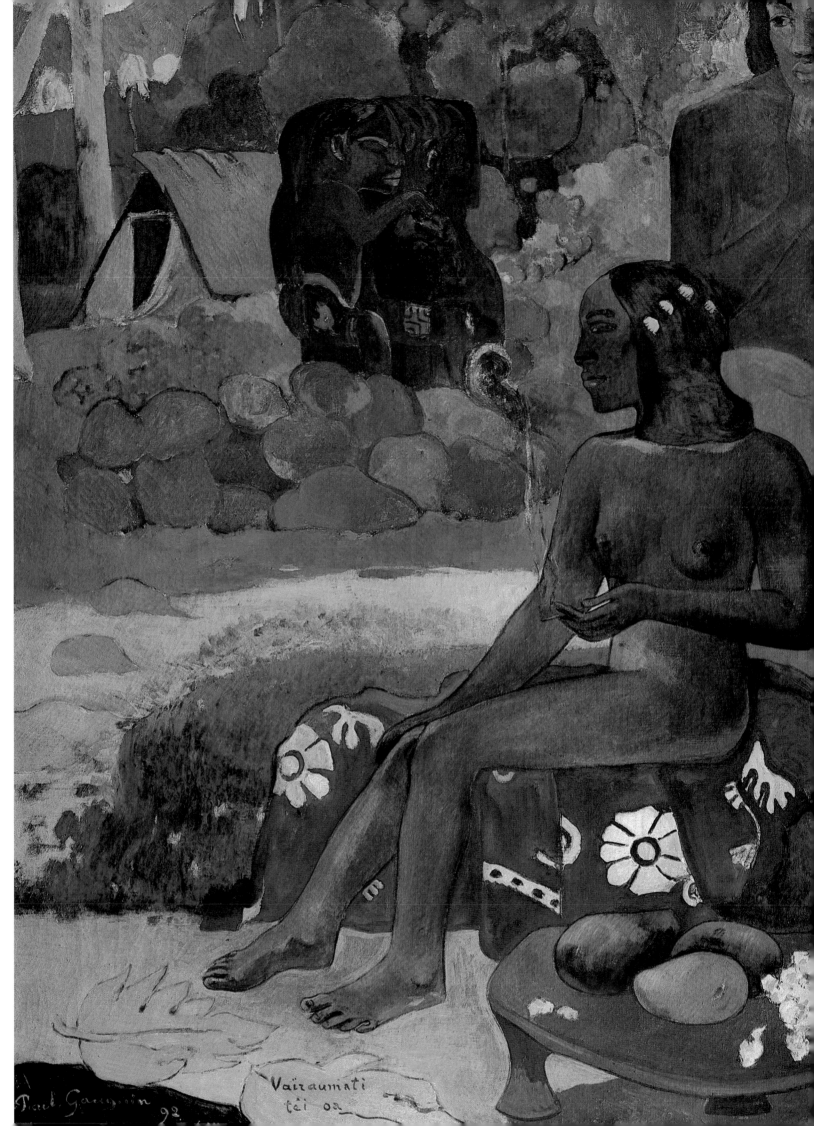

Paul Gauguin 92 Vairaumati tei oa

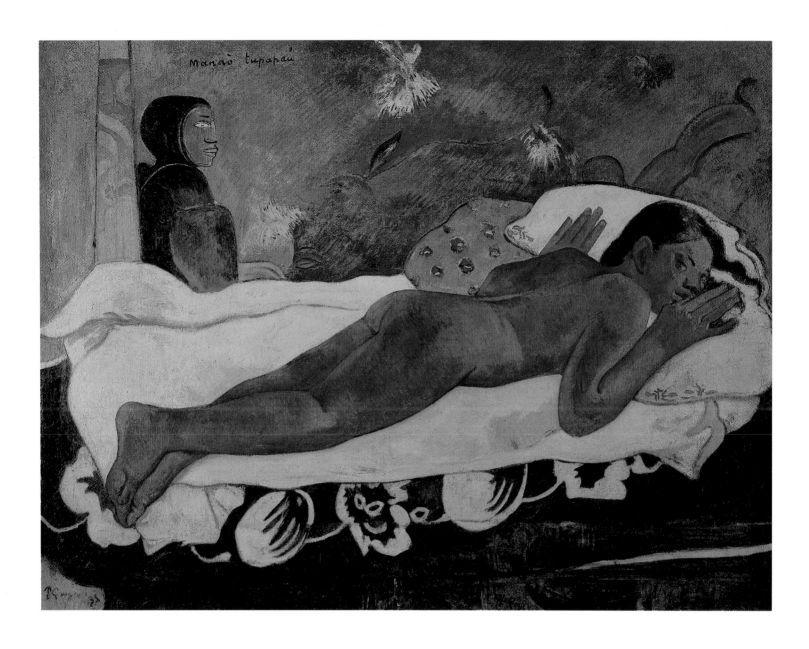

**The Spirit of the Dead Keeps Watch
(Manao tupapau), 1892**
Oil on canvas, 73 × 92 cm
Albright-Knox Art Gallery, Buffalo (N.Y.)

During the Tahiti years, Gauguin expanded his artistic repertoire
only slightly. In Brittany he had learnt how to alternate the figurative
and the abstract, how to use colour without reference to its represen-
tational function, and how to balance foreground close-ups with the
compelling pull of visual depth; and in the South Seas he employed
the same approach. But if his work did not develop in formal respects,
he certainly acquired new subjects. The change of environment, with
its unfamiliar greenery and myths, gave Gauguin a new artistic line to
follow. Time and again he described the paradisiac way of life he
claimed to have found. Call the brave new world an elysium, arcadia,
utopia or what you will, Gauguin discovered it all on Tahiti.

God's covenant with mankind applied in the South Seas too:
indeed, in that unspoilt, simple world the deity could even take a
human wife, and father a new and happier race of people. That, at
least, was what Gauguin's lover Tehura told him. The myth suited his
notions of Polynesia, and furthermore contained elements that were
familiar to a European. Zeus, after all, had occasionally had his plea-
sure of mere mortals. And the Christian God had singled out His
chosen people. According to Tehura, the supreme god Oro had fallen

in love with Vairaumati and had chosen her to be the progenitress of a people to whom paradise would be open wide. Gauguin related the myth himself in *Noa Noa*: "To receive him, Vairaumati had prepared a spread of the most wonderful fruits and a bed of the finest and rarest materials. Filled with divine grace and strength, they abandoned themselves to love in the groves and meadows. Every morning the god would return to the peak of Paia, and every evening he descended to sleep with her."

Her Name is Vairaumati (p. 51) illustrates the story. The exotic beauty is seen waiting for her lover, smoking. At present he can only be seen in the form given him by man, as a stone idol dominating the background. Choice fruits and costly fabrics are there, and all is in readiness for homage to be paid to the god.

In this work, Gauguin takes a different approach to that favourite theme of his, the intrusion of the supernatural into day-to-day life. Instead of contrasting both areas, he presents the figure of Vairaumati (so reminiscent of ancient Egyptian tomb reliefs) as containing the extraordinary character of the event within her, as it were. That sense of something alien which we have when we look at Egyptian images stood Gauguin in good stead in this picture: to the artist,

Near the Sea (Fatata te Miti), 1892
Oil on canvas, 67.9 × 91.5 cm
National Gallery of Art, Washington

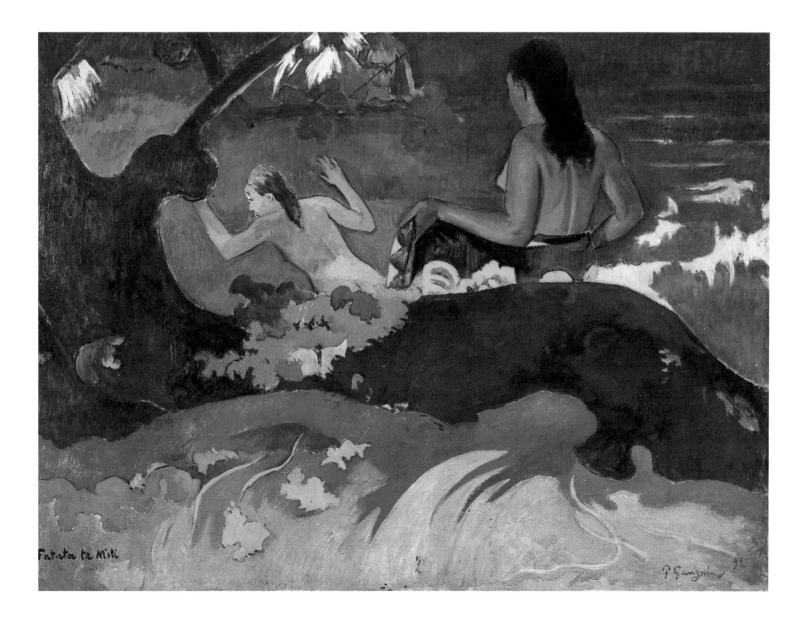

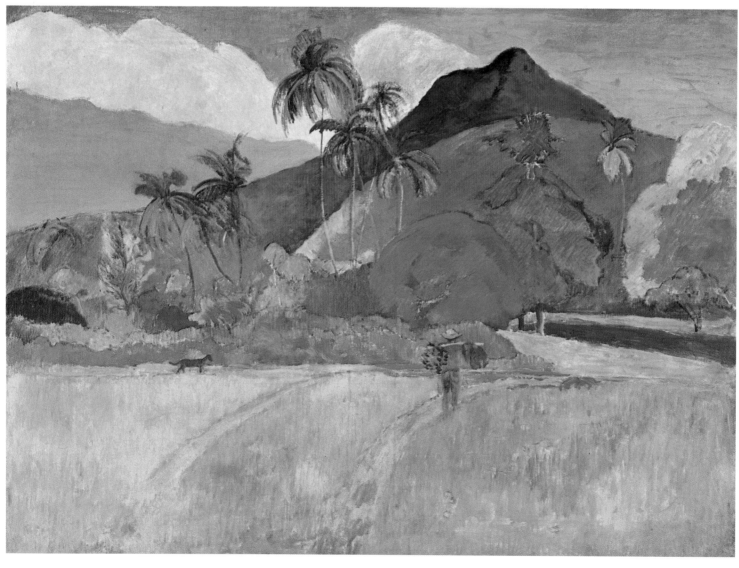

Polynesian myths are as extraordinary as the hieroglyphs of the ancient people of the Nile.

In *We shall not go to Market Today* (p. 48) Gauguin once again avails himself of ancient Egypt's schematic visual language. Here, however, the rigid row of five figures looks like a quotation, and seems unmotivated. There is no real connection between the formal arrangement of the figures, alternating between frontal and profile views, and the simple scene which is the painting's subject. Gauguin learnt the lesson and made no further attempts to adapt the style of ancient Egyptian art.

Gauguin had to rethink. The emotional universe of the people among whom he was living was not the mixture of instinct and superstition which he would have liked to suppose. Little by little he gained better access to it, mainly through the daily presence of his lover, Tehura. Then one night the gap between the two cultures was strikingly revealed to him. Gauguin returned late to the hut they shared, and struck a match to find his way about. Tehura interpreted the flame's flickering glare as the appearance of the spirit of the dead and was seized by mortal fear — though to the European the match was no more than an everyday object.

"What I saw was simply fear," Gauguin recalled when he described the episode. "But what kind of fear? Not the fear of Susanna surprised by the elders, that much is certain. That fear is unknown in Oceania. But the Tupapau, the spirit of the dead, had appeared. The Tahitian people live in constant fear of him."

When Gauguin came to express the experience in artistic terms he called his painting *The Spirit of the Dead Keeps Watch* (p. 52). Tehura is lying on the bed, naked. It is no wide-open pose of animal innocence such as a European's lascivious eye might be looking for. Instead, the woman is keeping her legs together, tensely, and is resting her hands on the pillow as if she were about to jump up and run away at any moment. Once again the supernatural has invaded the realm of everyday life. The awesome dark figure with its strong profile, and the impenetrable background with its hints of glittering apparitions, tell us that Tupapau, the spirit of the dead, is up to his mischief. His satanic infiltration of this tropical paradise stands for the ubiquitous presence of Death: even in this island people must die. For once (and only once) the harmony of Man and Nature which Gauguin stage-managed so skilfully is seen as null.

Tahitian Landscape (p. 54) shows that it was possible to forget such cares. Again we see the scenery reproduced in glowing colours, with all the freshness and immediacy of nature expressed in the sumptuously atmospheric colouring. The sheer purity of the colours goes beyond realism and offers a sense of hedonistic security: a harmony, or unity, is established, in which both man and the landscape are enlivened. At the same time, an ascetic harshness in the picture saves it from lapsing into the idyllic. The dog, and the man carrying the two bundles in weary balance, are scaled down by the landscape, becoming silent elements in a natural scene where everything has its rightful and necessary place.

Tahitian Eve, ca. 1892
Watercolour, 40 × 32 cm
Musée de Peinture et de Sculpture, Grenoble

TOP LEFT
Musique barbare, ca. 1891–93
Watercolour on silk, 12 × 21 cm
Private collection, Basle

BOTTOM LEFT
Tahitian Landscape, 1893
Oil on canvas, 68 × 92 cm
Minneapolis Institute of Arts, Minneapolis

Words of the Devil, ca. 1892
Pastel, 76.5 × 35.5 cm
Kupferstichkabinett,
öffentliche Kunstsammlung, Basle

But the Shangri-la which Gauguin depicted in these paintings was plainly unable to satisfy all his wishes. Money didn't grow on Tahiti's trees — and Gauguin had failed to free himself of the desire for money. "The way my fortunes take such a dive the moment I leave Paris is terrible," he moaned. "Yet the minute I return I find ways of earning my living. And as soon as I'm away again I don't make a penny." The modest success he had had with sales of pictures in his exhibitions was a thing of the past. Now he wanted to revive that success, and use his South Seas paintings to establish himself once and for all on the artistic scene.

Indeed, he had not prospered on Tahiti. The year before he had suffered several heart attacks; he had grown very thin, and felt tired. Taking a cool look at himself, he noted: "If I were to see things properly I would give up painting when I return, since I can't live on it." On the other hand, he felt a certain pride; after all, he had managed to stick it for three years. "I'm right in the thick of it!" He used the letter of recommendation which had got him his ceremonial welcome to finance his return journey.

In leaving Tahiti, Gauguin was saying goodbye not only to the island but also to the delusion that he had found the happiest corner of the world to live in. The delusion had been fruitful, guiding his brush and pen alike, and the evening before his departure he succumbed to it once again: "Farewell, you exquisite, hospitable land of beauty and freedom! Indeed, these ignorant savages have taught the old civilized crew a thing or two: many an insight, and the art of being happy." And, forgetting everything that had not been to his taste, he declared: "I leave two years older but twenty years younger — more of a savage than I was when I came, yet nonetheless knowing more."

When will you marry? (Nafea Faa ipoipo?), 1892
Oil on canvas, 101.5 × 77.5 cm
Rudolf Staechlin Collection,
Kunstmuseum, Basle

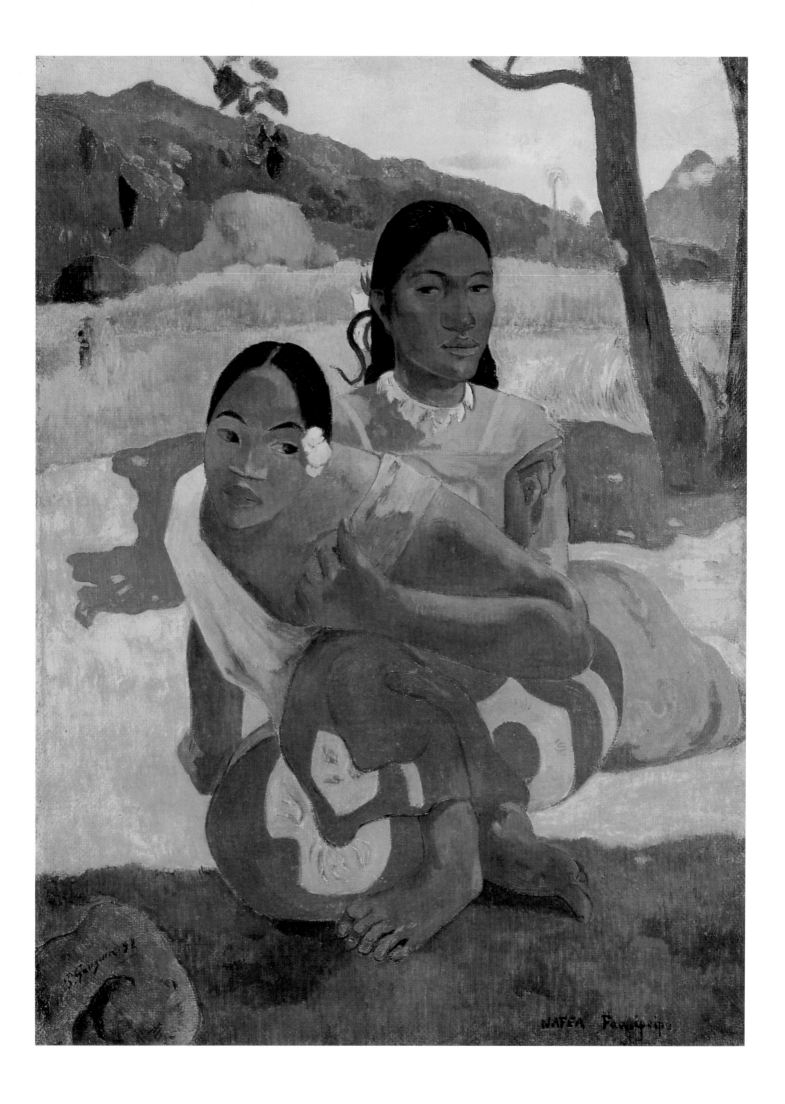

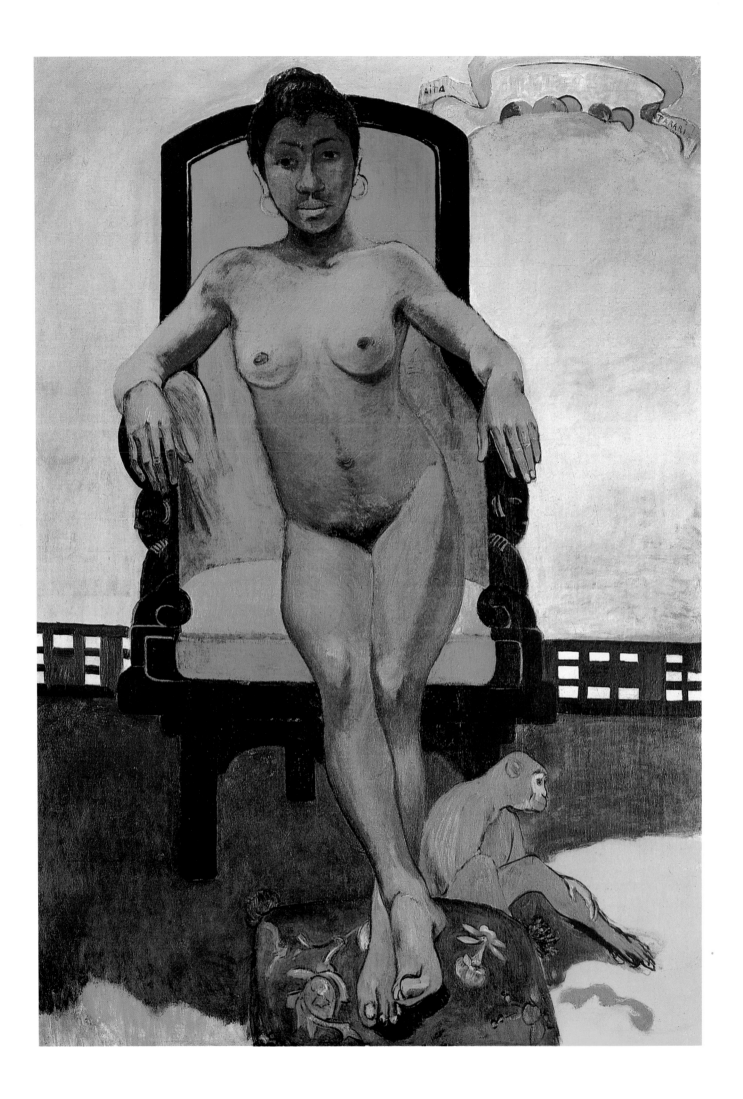

"The Greatest Modern Painter"
1893–1895

Gauguin's modest fame had not entirely faded away during his absence from France. Morice the critic acted as his agent in the Old World, and in fact succeeded in selling quite a number of Gauguin's Tahitian paintings back home. And then, at the beginning of September 1893, the artist himself was on the spot again, eager to have the French francs he had earned safely in his own pocket. But it was as difficult to track down the people who owed him money as to locate the unsold pictures. Gauguin spent the first few days after his return collecting outstanding debts.

And then there was his family of fatherless children. Mette had been selling her husband's paintings, thinking in that way to avoid being a burden on him, and now she felt justified in making demands. And the demands rose steeply after Gauguin's Uncle Isidore left 15,000 francs to his nephew.

Gauguin, confident of success, felt that such a sum of money was best invested in leading an artist's life, and considered that the requirements of wife and children came second, after that lofty goal. Quarrels over the legacy further estranged the artist and his wife and helped create new enmity. Gauguin could no longer expect support from his family in his homeland.

This meant that he had to be all the more prolific as an artist. He was preparing a retrospective show, with the aim of demonstrating the consistent logic of his development and the distance he had kept from the cheerful impressions recorded by a Monet or Renoir. Again it was an Impressionist who came to his assistance. Degas succeeded in persuading gallery-owner Paul Durand-Ruel, who handled his own work, to showcase the South Seas romantic on his premises. Durand-Ruel had made himself a name as the trailblazer of modern art; and Gauguin scented his big chance.

Gauguin was fully alert to the value of an artist's image in influencing the sympathies of an undecided public, and he therefore used Uncle Isidore's legacy to set up a new studio. He presented himself as an ambassador from tropical parts, who could lighten the dismal days of his clientèle with exotic magic. Thus his flat was crammed with whatever looked in any way "primitive": native and folk art, his own paintings, glass painting. The apartment was a miniature world fair. Above the front door were the mysterious words "Te Faruru" ("this is a

**Study for 'When will you marry?'
ca. 1892**
Pencil, charcoal and pastel,
53.3 × 47.8 cm
Art Institute of Chicago, Chicago

**Anna the Javanese (Aita Tamari vahina
Judith te Parari), 1893**
Oil on canvas, 116 × 81 cm
Private collection

Two Breton Women on the Road, 1894
Oil on canvas, 66 × 93 cm
Musée d'Orsay, Paris

place of love"). This was to be the kind of bohemian rendezvous which Mallarmé had hosted years before.

His image required that he should have an exotic lover, and Gauguin had one in Anna, the Javanese girl, who would dance with a little monkey for society gentlemen. In *Anna the Javanese* (p. 58) Gauguin aiming at the same unforced, natural nakedness as in his portraits of Tahitian women. But this time the relaxed animal quality doesn't quite come off. This woman, clothed by Nature in innocence, has not undressed — she has *been* undressed, by the covetous eyes of male society. In Paris, her very body helped create an image of exotic magic, and that is what she personifies in the painting. It is no chance (as it might be in the South Seas) that the little monkey is sitting at her feet; it is there as her attribute, to ensure that she will be recognized. Doubtless it pleased Gauguin to enhance his own image with the decorative Anna; but in this work he was unable to give effective artistic expression to that direct fascination with the beauty of local women which had given such distinctive power to some of his Tahiti pictures. The painting seems as contrived as the exotic atmosphere of the artist's studio.

In Paris, Gauguin liked to encourage notions of the artist as one who envisioned a better world, and the book edition of *Noa Noa* fitted

splendidly. It was conceived as an artist's diary, with its gaze firmly fixed on the tropics, and despising the reality of its own origins. *Noa Noa* is not an especially truthful book, but that is beside the point. Gauguin merely needed a consistent narrative, and a story that matched his attention-getting public image. He had made a diplomatic peace with Morice, and the critic wrote a few poems for the book. And Gauguin took on the task of illustrating it himself.

In the watercolour *The Messengers of Oro* (below) we sense something of Gauguin's mood at that time. It tells of events immediately preceding the episode Gauguin presented in *Her Name is Vairaumati.* The two sisters of the supreme god Oro are telling the young virgin cowering on the ground of Taaroa's wish to take her as his bride. Back home, Gauguin was still dwelling on images seen in the South Seas. Instead of being receptive to new subjects, he was drawing on a repertoire acquired during the past few years. He was hoping, of course, that he would overwhelm the art world. But in fact this divorce

The Messengers of Oro, 1893
Illustration for 'L'Ancien culte mahorie', leaf 24
Watercolour, 14 × 17 cm
Département des Arts graphiques, Musée National du Louvre, Paris

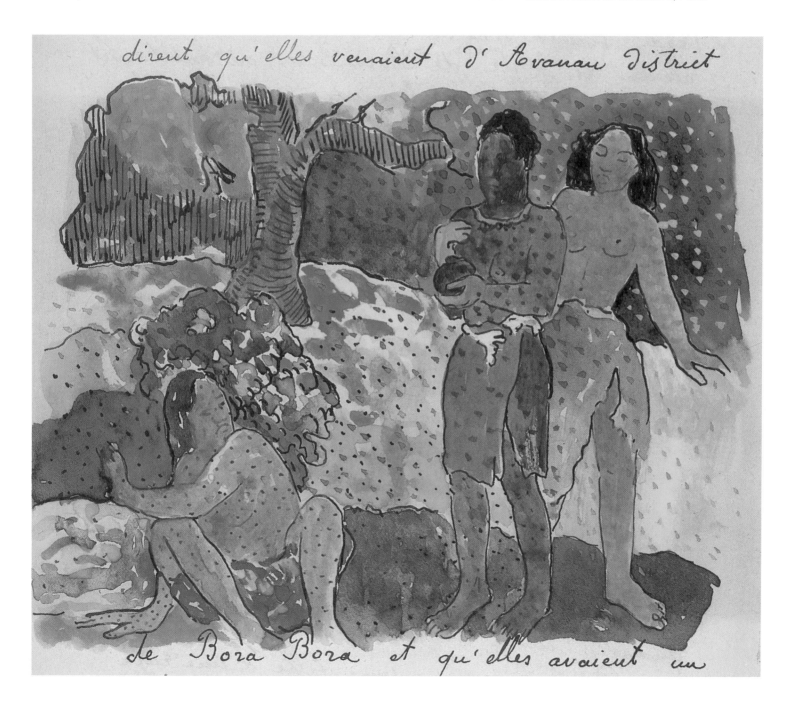

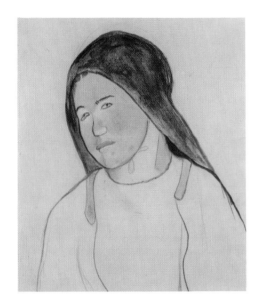

Head of a Young Breton Peasant Woman, ca. 1894
Pencil, red and black chalk, wash,
22.4 × 20 cm
Fogg Art Museum, Harvard University
Cambridge (Mass.)

The Cellist (Portrait of Upaupa Schneklud), 1894
Oil on canvas, 92 × 73 cm
Baltimore Museum of Art, Baltimore

from the facts of his surroundings (in an artist whose visual world had always depended heavily on the people, plantlife and folk art around him) was to play its part in alienating Gauguin from his homeland. Even in Paris, the artistic capital of Europe, with such a wealth of subjects to offer an artist, Gauguin was sustained by his memories of the tropics.

The exhibition at Durand-Ruel's gallery had now opened, in November 1893. The French yearning for the magic of the South Seas was amply catered for in Gauguin's forty-six paintings and two sculptures. Nevertheless, he had failed to catch the public's taste: critics complained that his work was too crude and too primitive, and that his "rape of the basic elements of drawing" was "coquettish". Press ridicule peaked in the advice: "If you want to amuse your children, send them to the Gauguin exhibition!"

When he set off for Tahiti, Gauguin had been perfectly willing to play the rejected outsider, but meanwhile he had fitted in again, stylishly and adaptably, only to find himself rejected anew. At least his fellow-artists applauded, and put in the right words for him. And at least he sold eleven of his works. At the beginning of 1894 he exhibited with *Les Vingt* in Brussels, and (unlike *Vision after the Sermon*) received considerable praise for *The Spirit of the Dead Keeps Watch.* Immediately, Gauguin was in the best of spirits again. He wrote enthusiastically to Mette that he had finally been recognized as "the greatest modern painter".

Gauguin's hunger for success was most clearly visible in the way he stubbornly clung to his South Seas subject matter. Paintings such as *Day of God* (p. 64) and *Delicious Water* (p. 65) were still full of the magic of his lost world: gently the artist was trying to rediscover that way of seeing which sensed the harmony of Man and Nature. Gauguin still had enough affection for his old, civilized world to think it could be improved by the visions in his paintings.

The Cellist (Portrait of Upaupa Schneklud) (p. 63) was one of the most successful pictures Gauguin painted in France, because he was able to put the tropics aside. The artist is trying to reproduce the sounds of music with his own means — a variation on the synaesthesia he had experimented with on Tahiti. Music and painting meet in the two gently-curved lines that link the right arm with the abstract pattern in the background. The picture is filled with a sense of movement: the swing of the arm that is producing music is continued, as it were, in an ornamentation which is equally suggestive of music. In this portrait of an artist alert in his senses and emotionally open, Gauguin expressed all his own hopes of regaining touch with the roots of his own culture.

It was only consistent, then, that Gauguin should think of revisiting Brittany. The spartan landscape of the Atlantic coast brought to mind his own roots. He wanted new mental stimulus, and was hoping that the artist friends he had once worked alongside would reinforce his self-esteem. But there was no one there any more: the artists had dispersed, his friends had moved away. His stay in the provinces became a nightmare. It was to scar him deeply, both mentally and physically. On an outing to Concarneau, he and Anna and a couple of

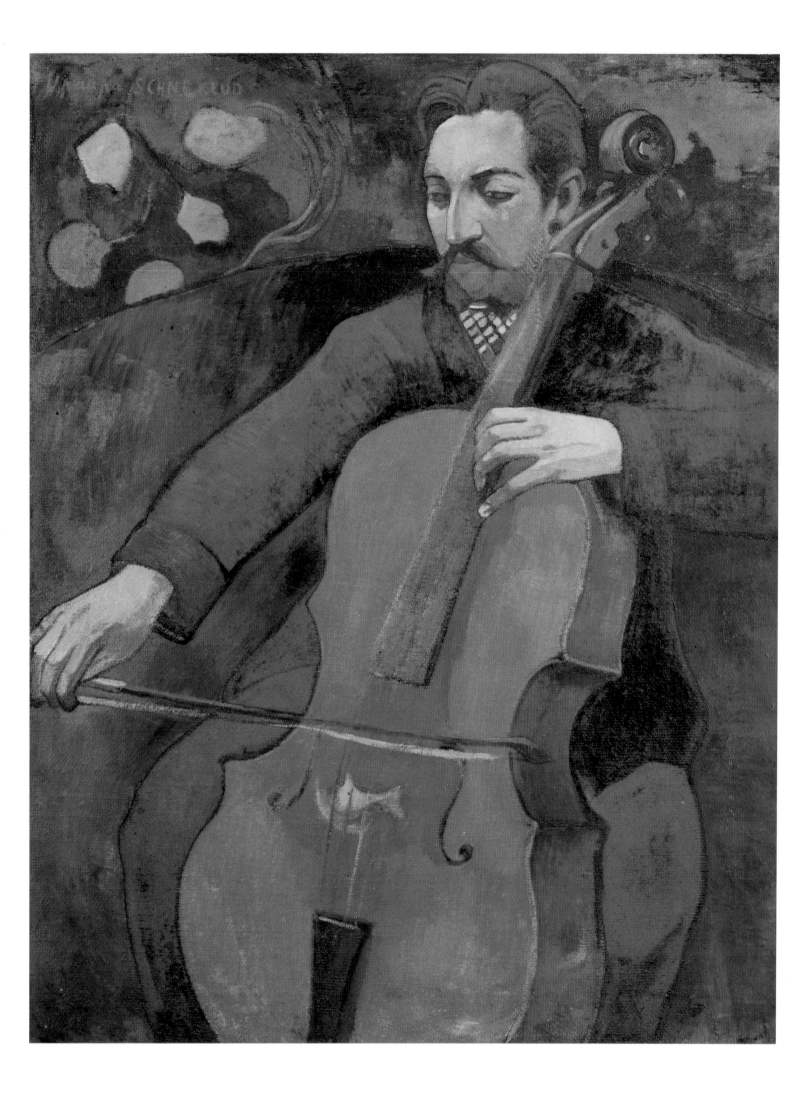

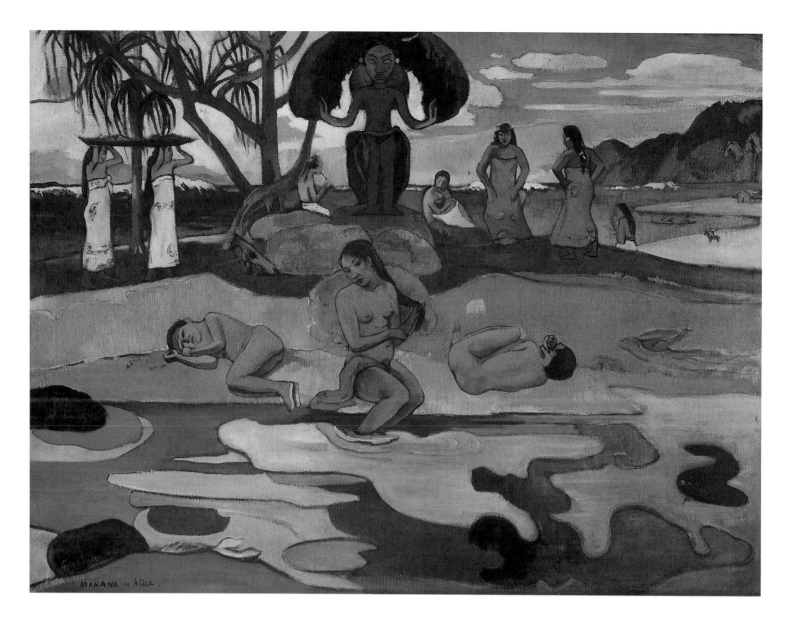

Day of God (Mahana no Atua), ca. 1894
Oil on canvas, 66 × 87 cm
Art Institute of Chicago, Chicago

friends got into a squabble with some children. Local sailors came to the youngsters' assistance, and in the ensuing brawl Gauguin broke his ankle. The foot was never to heal fully, and in fact, gave him considerable pain during the last years of his life. While he was being looked after in hospital, Anna deserted him, first ransacking the flat they had shared in Paris.

The Concarneau brawl resulted in legal proceedings, which Gauguin lost, just as he lost an attempt to make dealers and friends restore his own works to him. The experience left him determined to avoid future disappointment at the hands of civilization: "Nothing will stop me leaving, and this time it will be for good. What an idiotic existence life in Europe is."

Maybe Gauguin would have been appeased if his auction of work (to finance his departure) had been more of a success. But this time the auction, held at the Hôtel Drouot in Paris, was a disaster, and he sold almost nothing. Gauguin had to buy his own pictures to meet the asking price. Friends also left him in the lurch. He had asked dramatist August Strindberg to write a catalogue preface for the sale, but the Swede, declining the invitation, expressed himself suggestively: "Monsieur Gauguin, I said in a dream, you have created a new earth

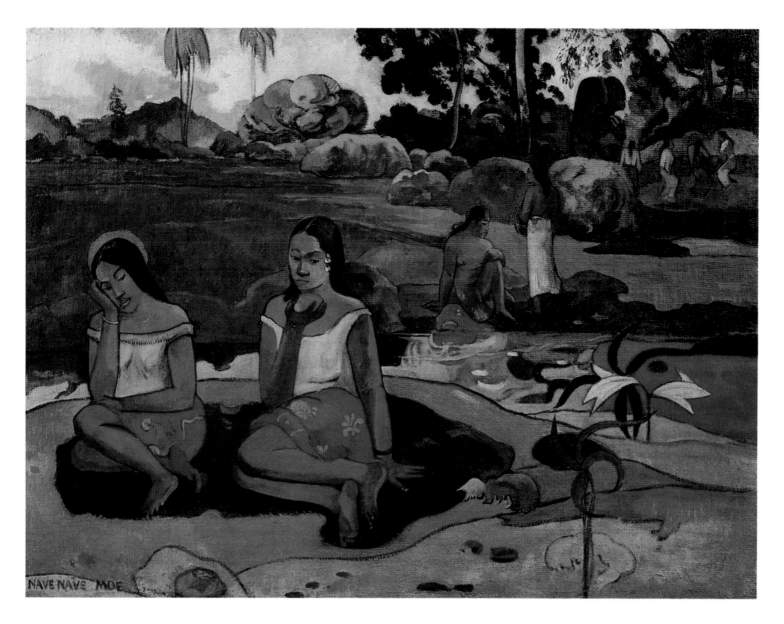

and a new heaven. But I do not like what you have created." So Paul Gauguin at last felt totally deserted. He had returned to Europe full of hope, prepared to play the fashionable game of exotic magic, but he was unable to play the game as wholeheartedly and relentlessly as the public expected. He was too committed to the truth of his vision of the tropics. Failure was inevitable. There was nothing to keep him in Europe any longer. And when he left, he left an angry man.

Delicious Water (Nave Nave Moe), 1894
Oil on canvas, 73 × 98 cm
Hermitage, Leningrad

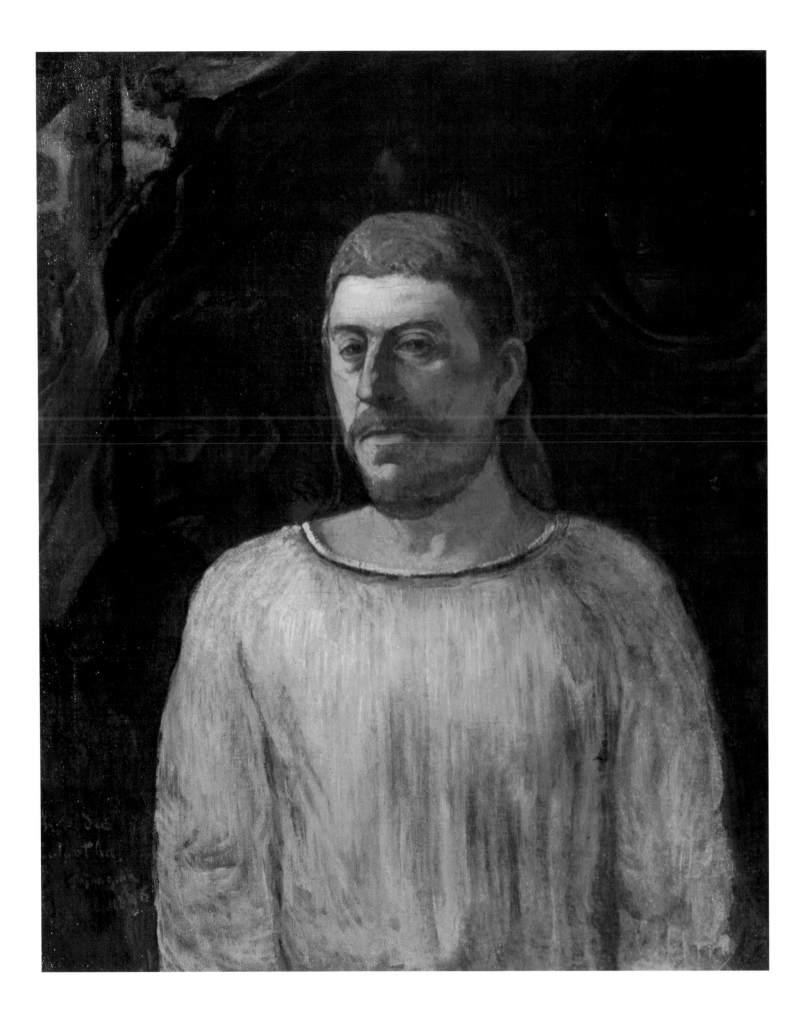

The Legacy of the Tropics
1895–1903

"Paul Gauguin has no cause to be proud of his fellow-countrymen. Those who were astonished some years ago when he chose Tahiti as an idyllic exile where he could work in peace and sunshine might seek the reasons for his second departure in the ingratitude with which they themselves responded to a man whose life's work and reputation are among our most valuable possessions."

Thus wrote a chastened Morice, when he heard the news that Gauguin had once again quietly departed from France, without a hint of going-away festivities.

Morice was one of the few that viewed his course positively. Most of Gauguin's fellow-artists felt immensely provoked by his approach: after all, they too were convinced that they had a mission to revolutionize art, but they wanted the grand upheaval to take place on their Parisian home ground if at all possible, or during their summer vacations in the provinces. Inevitably Gauguin antagonized them; his relentless pursuit of outsider status was a continuous and pointed reminder of their own indolence. Deep down, they may well have heaved a sight of relief to be rid of their friend.

Gauguin's voyage to the other side of the world took three months. He made it in a spirit of disillusionment, and in the event it was to be a journey of no return. Henceforth, the artist preserved only letter contact with France, normally on a monthly basis. The return to the home country had not provided the inspiration he was constantly in search of, and the increasing daring and freedom of his art had gone largely unrecognised in society. The fact that some of his fellow-artists did indeed value his achievement was of little direct assistance in the day-to-day business of living.

Things had changed somewhat in Tahiti. The town of Papeete had had electricity laid on and had acquired a new governor, a more flexible spirit with whom Gauguin toured the island. At first the painter was filled with optimism about his new life in the tropics; though there were those back home who had their doubts.

His old friend Schuffenecker, reviewing the course, which events had taken, wrote to Gauguin: "If you had been clever and planned ahead, you would now be leading a pleasant, carefree life." In other words: if you had proved more adaptable, the public would have rewarded you accordingly.

Mysterious Water (Pape Moe), 1893
Watercolour, 31.8 × 21.6 cm
Art Institute of Chicago, Chicago

Self-Portrait, 1896
Oil on canvas, 76 × 64 cm
Museo de Arte, São Paolo

**Why are you angry? No te aha oe riri?,
1896**
Oil on canvas, 95.3 × 130.5 cm
Art Institute of Chicago, Chicago

But this criticism was first and foremost that of a conformist who had abandoned art for a safe job as an art teacher, and Gauguin could hardly accept it. "I never intended to go cap in hand to the state," wrote the painter. "Everything I struggled for outside the realm of officialdom, and the dignity I have tried hard my whole life long to maintain, have become worthless from this day forth. From now on I am no more than a schemer and a big-mouth. But if I had given in – yes, then I would be sitting pretty."

Working himself up into a fury, he cast himself in the role of a monster: "I shall end my days here in my peaceful hut – yes, I am an awful wrong-doer. So be it! So was Michelangelo – and I am not Michelangelo!" That proverbial *terribilità* which at one fine raged volcanically within the Renaissance hero was now exported to the South Seas in the exile's baggage.

The artistic avant-garde has always envisaged society as a straitjacket, imposing limits on the freedom of the imagination. The avante-garde sees the possibility of creativity as existing only in opposition to the state's models and norms. The artist dons the garb of genius and proclaims a freedom which (as he knows) cannot be available to all. If he is to justify his demand for societal freedom, he

must needs insist on his calling, his vocation. Gauguin too found himself manoeuvred into this position. And, on top of it, he tended increasingly to give himself a martyr's airs: "What did it get me? Total defeat, and enemies — that's all. Bad luck has been dogging my heels my whole life long, and the further I go on the deeper I sink."

Thus in the *Self-Portrait* (p. 66) we see Gauguin posing as Christ once again. This time however, he attempted no self-satisfied comparison with the Christian God. The artist's gaze was one of straightforward accusation. "This terrible society which we are forced to endure, where little men emerge triumphant at the expense of great, is our Calvary," he wrote three years later. But he was not only attacking his favourite enemy, the Old World. The portrait is set against a dark and impenetrable background where two vague figures are appearing, constant companions from the realm of the shades of Death. The artist looks calm, resigned to his fate as outsider, a man

Eiaha Ohipa (Not Working), 1896
Oil on canvas, 65 × 75 cm
Pushkin Museum, Moscow

like any other: helpless and defenceless. After years of searching, Gauguin had at last found in this Janus face an emblematic portrayal of life itself. His sensitivity towards the special status of the artist who is certain of his visionary faculty merged with an admission of that frailty he shared with all men, be they primitive or civilized. Caught between loneliness and solidarity, Gauguin began to accept himself: "Laughing, you climb your Calvary, your legs shake under the weight of the cross; at the top you grind your teeth, and then, smiling, you take your revenge," he wrote cryptically in *Avant et après,* his memoirs of the closing years of his life.

Since the thought of hanging his work on western walls no longer dominated his thinking so much, Gauguin's pictures were now quite often of monumental size, and lost that aura of contrivance and artifice which had seemed programmatic and forced in his earlier South Seas work. He continued to send his paintings to his European agent, Daniel de Monfreid; but now Gauguin abandoned the misconceptions which, after his repeated failure, he ought to have given up long before. Now he paid attention to a voice within, to a need for truth. Now he increasingly refused to strike artistic compromises between the gentle naturalness of the local people and the expectations of his European audience.

And now Gauguin attempted comparisons of ways of life, trying to analyse in detail the respects in which the civilized and primitive worlds differed. *Eiaha Ohipa* (p. 69), for example, contrasts the Euro-

Still Life with Mangoes, 1896
Oil on canvas,
private collection

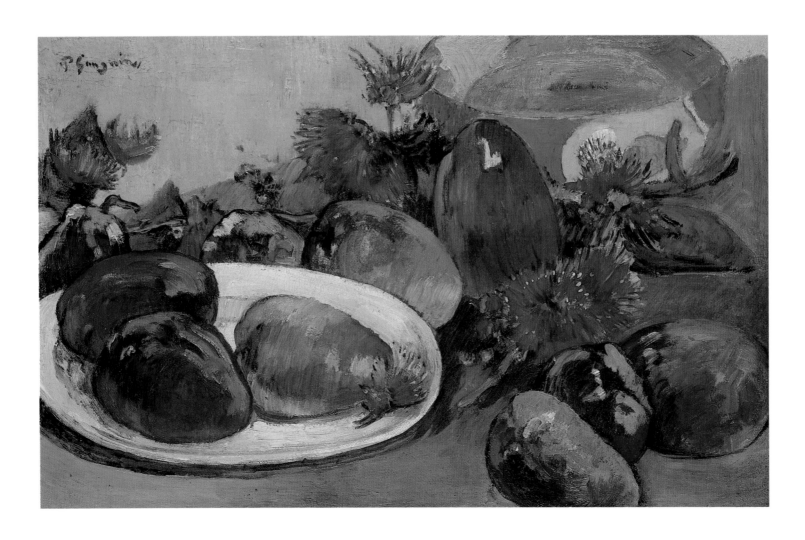

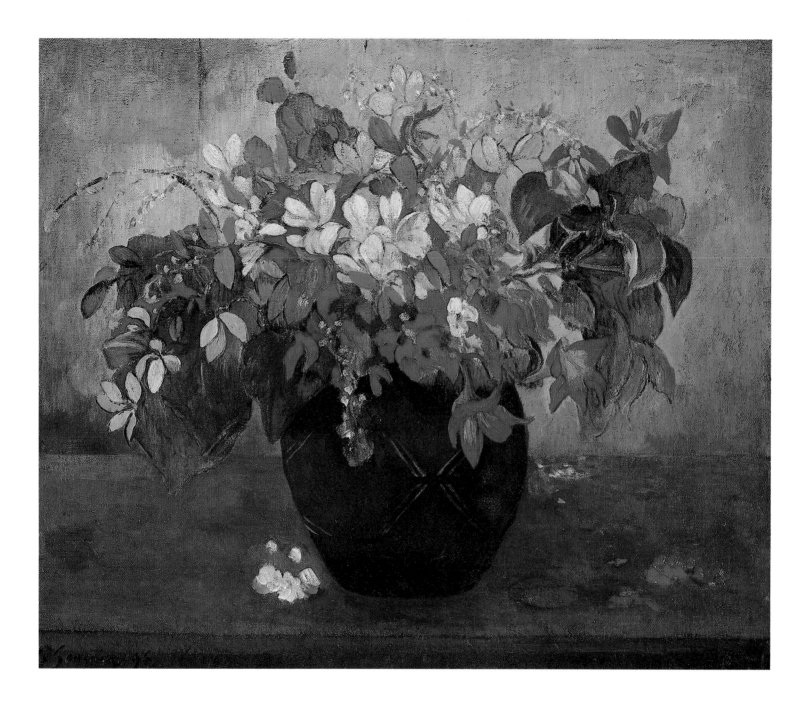

pean work ethic (which still had Gauguin himself in its grip) with the Tahitian tendency to take things as they came. Two Tahitians are sitting in their hut, sleepily enjoying their tobacco. There are no tools or materials to prompt them to hard work. In the background, a figure in a long, white robe, with a topee on his head, is seen approaching — none other than the artist himself. Searching for subjects (that is, for things that will set him working) he has hit upon the theme of work; and now he produces affectionate sketches of a world devoted to doing nothing, to idleness of a kind he himself is incapable of. The artist lacks the natural, animal freedom of these people, who are indeed so like the animals (and all of creation) — animals such as the cat, sleepy and unself-conscious too, and without any fear of doing the wrong thing.

"When I am tired of painting human figures (which is what I prefer), I start a still life and complete it without referring to the objects again," Gauguin wrote to the Russian Prince Emanuel Bibesco, one of his

Bouquet of Flowers, 1896
Oil on canvas, 63 × 73 cm
National Gallery of Art, London

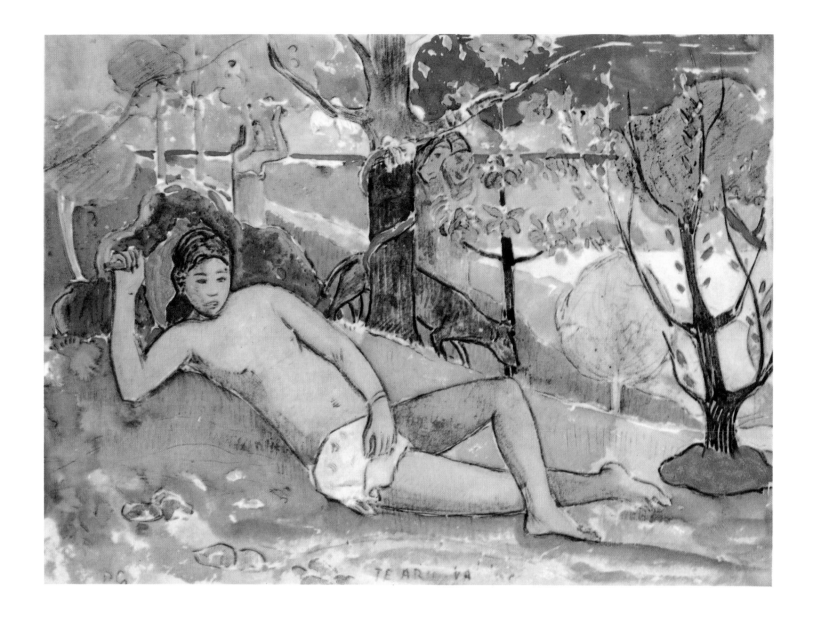

Queen of Beauty (Te Arii Vahine), 1896
Watercolour, 17.2 × 22.9 cm
Private collection, New York

collectors. (There were a number of Gauguin collectors, in spite of the artist's setbacks.) He wrote of still lifes as if painting them were relaxation: clearly leisure was not synonymous with idleness for Gauguin. Whatever he may at times have said, he was no native, and had his work ethic. *Still Life with Mangoes* (p. 70) and *Bouquet of Flowers* (p. 71) show Gauguin in holiday mood. He presents flowers and fruits in the same way as people, with vivid immediacy and a sensuous fascination; whether animate or inanimate, everything in creation is a part of nature.

Gauguin soon moved away from the Tahitian capital Papeete, as he had done the first time. The influence of Europe was worse than ever: now electricity had been introduced to the island. Once again, Gauguin moved to the interior, into a frail and rickety native-style hut exposed to the elements.

"I have straw matting and my old Persian carpet on the floor," he wrote to Monfreid. "The place is adorned with materials, knick-knacks and drawings." This time Gauguin had to do without his lover Tehura, since she had got married in the meantime. Still, he wrote to friends that "girls come to my bed every night as if possessed", doubtless intending to prompt envy back home. His new lover was a fourteen-

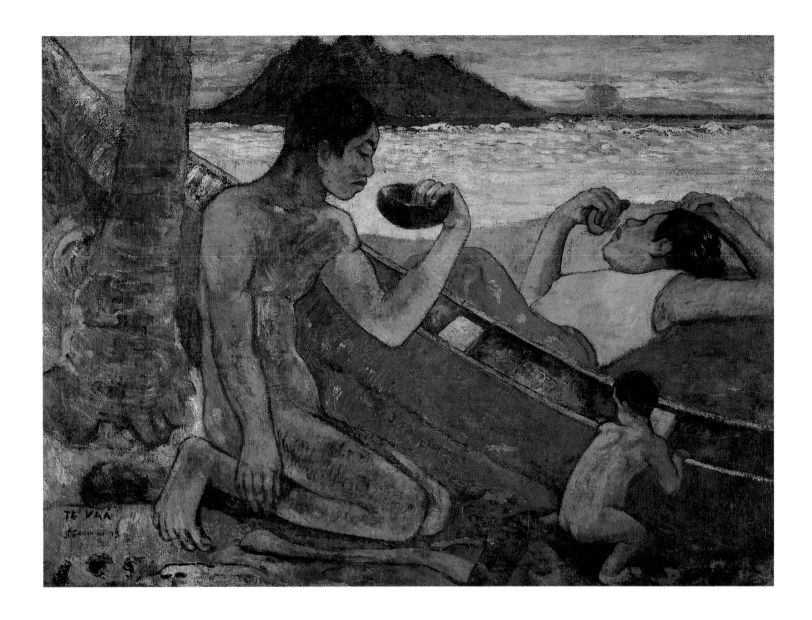

The Dug-Out (Te Vaa), 1896
Oil on canvas, 96 × 130 cm
Hermitage, Leningrad

year-old called Pau'ura. His love life, however, was plagued by an unpleasant legacy from France: shortly before leaving Paris he had contracted syphilis, and now he found himself introducing his dearly-loved paradise to one of civilization's more dubious blessings – he passed on the disease to the Polynesians.

The beautiful female nudes that constitute the major part of Gauguin's late work might almost have been meant to illustrate his tales of girls succumbing to his erotic charisma. Thus *Queen of Beauty* (p. 72), a watercolour study for the oil *Woman with Mangoes* in the Leningrad Hermitage, shows the girl in a pose familiar from European art, lying on the grass in the same way as Goya's *Naked Maya* (Prado, Madrid) or Manet's *Olympia* lay on their vast beds. Her legs are crossed and she is covering her privates with her hand, offering herself in the same may as Goya's and Manet's lascivious goddesses of love did; but Gauguin's beauty is not looking at us, and her averted gaze mitigates the seductiveness which lies in that ambiguously fascinating figure, the innocent temptress.

"The Eve of your civilized imagination makes you and almost all of us misogynists," Gauguin had replied to Strindberg; "the Eve of primitive times who, in my studio, startles you now, may one day smile on

73

you less bitterly." The strict sexual morality of the late 19th century always saw erotic charisma together with feelings of danger or even hatred. On Tahiti, Gauguin wanted to free himself of this unnatural attitude to love and desire, an attitude which emphasized divided, mixed feelings rather than an immediate response. He wanted an Eve who could be loved without guilt. This Eve was a product of male fantasies too; but an imaginary innocent Eve seemed free and available, and her lover felt like a man once more.

"They are gentle-spirited to the point of stupidity, and totally incapable of mean calculation," Gauguin wrote of his Polynesian friends and neighbours in *Avant et après.* He was wholeheartedly willing to see the innocent simplicity of the local people as the true human condition. His friendly reception on Tahiti was quite the opposite of the derision and brusque rejection he had suffered in Europe. And so he inevitably felt an affinity with the people of the South Seas. If every being under the sun had its own natural dignity, cruelty was easily forgotten: "Ask one of these sleepy ancients if he likes human meat and, with a twinkle in his eye, he will answer cheerfully and infinitely gently, 'Ah, how good it tastes!'" reports *Avant et après.* The cannibal who devours the body of his enemy (but only his enemy) behaves more

Nativity (Te Tamari No Atua), 1896
Oil on canvas, 96 × 128 cm
Neue Pinakothek, Munich

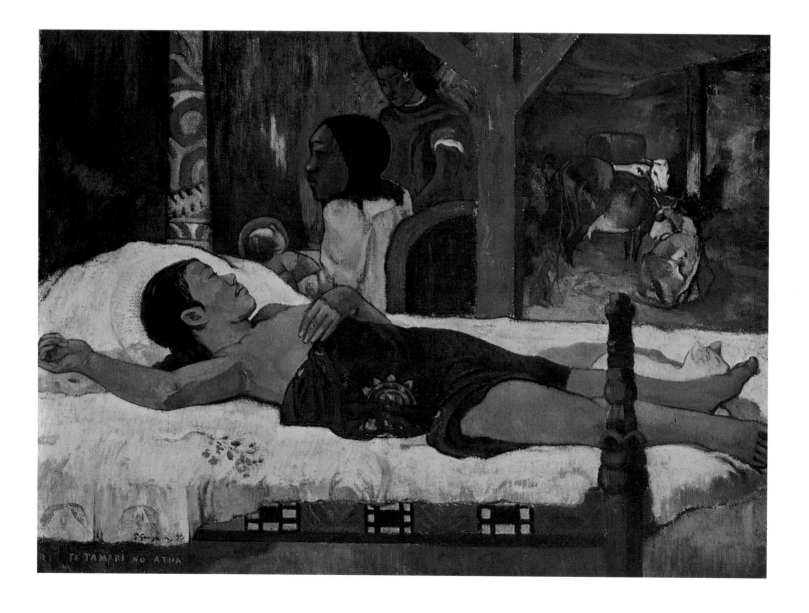

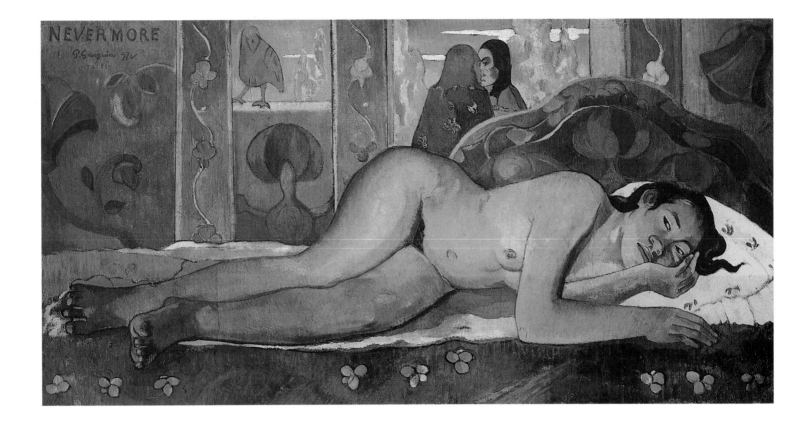

Nevermore, O Taïti, 1897
Oil on canvas, 59.5 × 116 cm
Courtauld Institute Galleries, London

morally than western society, which calls itself humane but locks people up for life in asylums. "I no longer have any sense of days and hours, or of good and evil." On that peaceful island, with its own standards and values, no one troubled with appointments; and, since their lifes were lived in harmony with nature, they could not but be good.

Gauguin himself flouted western convention quite blatantly at times. He fathered illegitimate children, for instance: one was born before he left Paris, and another one year later on Tahiti. The happy event soon appeared in paintings with family, procreation and birth as their subjects. The everyday bliss of family life is Gauguin's theme in *The Dug-Out* (p. 73). People drinking out of bowls, and a rudimentary boat to carry them over the water: everything is simple. The axe at the man's feet indicates that he has just made the dug-out. The family can find everything they need in their environment, which appears as a veritable Shangri-la, bathed in harmonious sunset tones. In this world, things take care of themselves, it seems, and the people's faces are relaxed, trusting, and utterly contented. Given the pleasure and peacefulness which fill the picture, the traditional symbolic meaning of a boat as a way of overcoming dangers is scarcely important. The whole family conveys the message – a message of harmony.

Borrowing the tradition of Christian art in his familiar manner once again, Gauguin put his own experience of fatherhood into his *Nativity* (p. 74). Again a biblical story has been given a South Seas setting – a Polynesian hut with ornamental beams and a simple bed. The stable animals are there too. A native woman, probably Gauguin's lover, has been cast as the Mother of God. Like the newborn child being rocked by the nurse in the background, she has a halo.

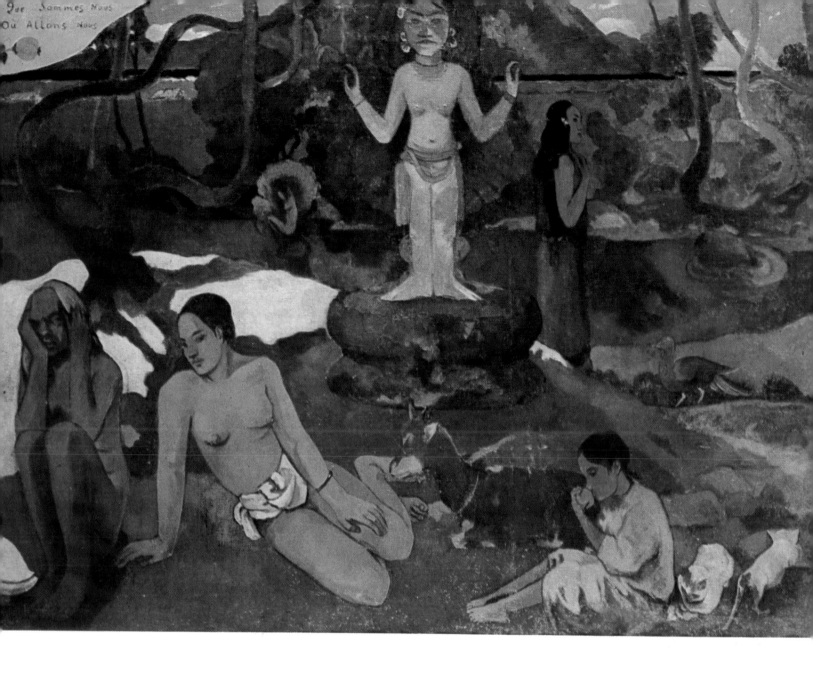

Again the artist draws a parallel between himself and the Christian God, though this time he has cast himself in the role of creator rather than sufferer. In this painting, Gauguin appears to be saying that the life which he is able to create is not only a product of artistic activity: at the end of his life, we see him once again proclaiming the values of fatherhood, which had originally established the individual character of his work. The serenity of the scene is resplendent and undimmed. That first year on Tahiti was surely one of the happiest in Gauguin's life.

But his situation soon deteriorated. Yet again he was plagued by financial worries. With the help of friends, he had tried to establish a group of patrons who would pay him an annual allowance in return for a number of pictures; but the plan didn't work out. Instead of the backing of wealthy patrons, Gauguin merely achieved a one-off grant of 200 francs from the Minister of the Arts. Vexed by such a small amount, the émigré returned the pittance in a temper.

Gauguin had no intention of begging. He longed for the recognition his artistic achievement had earned him. Unfortunately, he could have

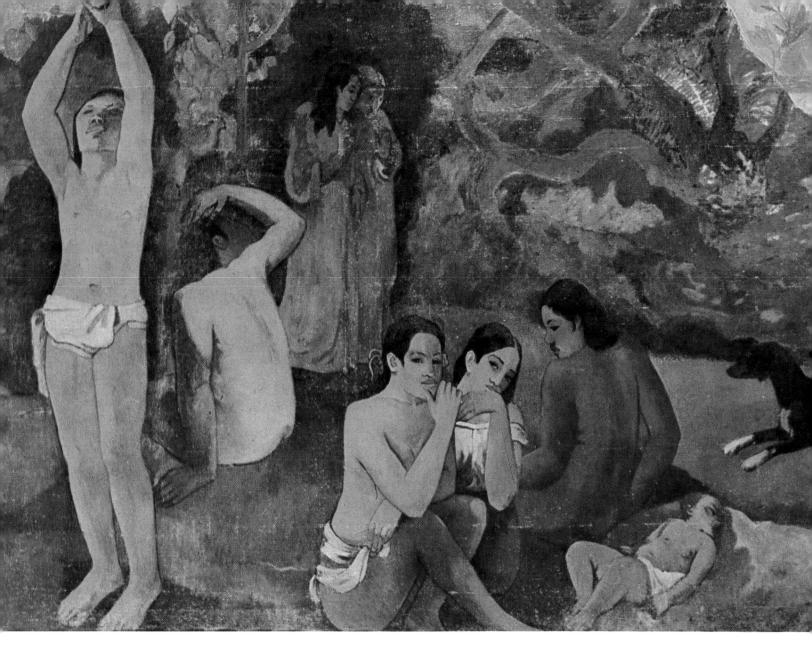

used the money: "My position is precarious and growing more and more unbearable, and, dreadful as it may be, I cannot afford protracted haggling. I shall have to sell my pictures for whatever price I can get."

In his self-imposed exile, Gauguin also knew that most of his paintings were unsaleable. When he sent *Woman with Mangoes* (compare the watercolour study on p. 72) to Europe, he wrote: "What's the point in sending this picture far away to join all the others that cannot be sold and only provoke howls of derision? This painting will only provoke still more derision. I am condemned to die of goodwill or hunger."

He reconsidered the possibility of adapting his work to public taste. To make matters worse, the broken ankle was giving him problems: his syphilis grew worse and turned into a running sore. Gauguin had to go into hospital for treatment which he could not pay for. His debts mounted.

Gauguin's new gloom promptly found expression in his work. *Nevermore, O Taïti* (p. 75) is another of his monumental nudes, with the

**Where Do We Come From?
What Are We?
Where Are We Going? (D'où venons-nous? Que sommes-nous? Où allons-nous?), 1897**
Oil on canvas, 139 × 375 cm
Museum of Fine Arts, Boston

77

Bouquet of Flowers, ca. 1895/96
Watercolour, 19.2 × 11.8 cm
Département des Arts graphiques,
Musée National du Louvre, Paris

distinctive nakedness of the earlier ones. But the very title suggests the clouds which were gathering above the artist. At the Café Voltaire banquet when Gauguin left, Mallarmé had recited his own translation of Edgar Allan Poe's poem 'The Raven', which uses the word "nevermore" as a refrain. The menacing raven in the poem is a bird of ill omen. In Gauguin's painting the raven appears in the background, an unprepossessing apparition that seems ornamental rather than real. It is joined by two sinister figures whispering secret words that bode no good. And the naked woman in the foreground, rather than lolling in natural, innocent abandon, appears to be listening intently. The dangers are in the background, arranged (as if on a frieze) on a flat, tapestry-like area that offers us no purchase on spatial depth. The sense of menace remains unfocussed but pervasive in the painting — and Gauguin's frame of mind was to worsen still further.

He seems to have lived in a mental state of emergency on Tahiti. Up one day and down the next, he lived in a rapid alternation of euphoria and depression. Barely a year after the exhilaration which had accompanied the birth of his child, he was emotionally at rock bottom once more. He was racked with thoughts of suicide.

In spring 1897 a letter brought him terrible news from back home. His daughter Aline, in whom a hopeful Gauguin had seen the greatest chance that one of his children would prove artistically gifted like himself, had died. In the reply he wrote to Copenhagen he scarcely veiled his feeling that his wife's severity was to blame for the girl's death: "I do not want to say 'May God watch over you,'" he remarked bitterly, "but rather, quite plainly, 'May your conscience rest — so that you do not find yourself longing for the release of death.'" Gauguin himself often longed for that release: "I have lost a daughter. I do not love God any more." His powers of imagination, however, were still as vivid as ever and in his mind his daughter — to whom for many years he had not been a good father, and who had hardly registered his existence — was with him: "The grave you have made her is a delusion. In reality she lies here with me." He wanted her buried in that better world which existed in the South Seas one moment and the next in the artist's head alone.

Gauguin set himself a deadline. If things had not looked up by next January he would kill himself. In 1897 a letter from Monfreid, enclosing much-needed money, had eased his troubles. Now, in setting himself this ultimatum, he was out to test his luck again; but this time there was no good fairy. As well as further torment with his leg he now had an inflammation of the eye and feared "that I shall never recover my health completely". And the financial problems remained acute: "I have no dealer, no one to guarantee that I shall have something to eat each day. How can I go on? I can see no way out but death — which will release me from everything."

Towards the end of the year he prepared to keep the bargain he'd made with himself. He had made a hell of the paradise he never tired of painting. Better men than he might live there if they liked, but he himself wanted to get out, to show that he did not belong there, however tirelessly he had wanted to be accepted on the island of the

The White Horse, 1898
Oil on canvas, 140.5 × 92 cm
Musée d'Orsay, Paris

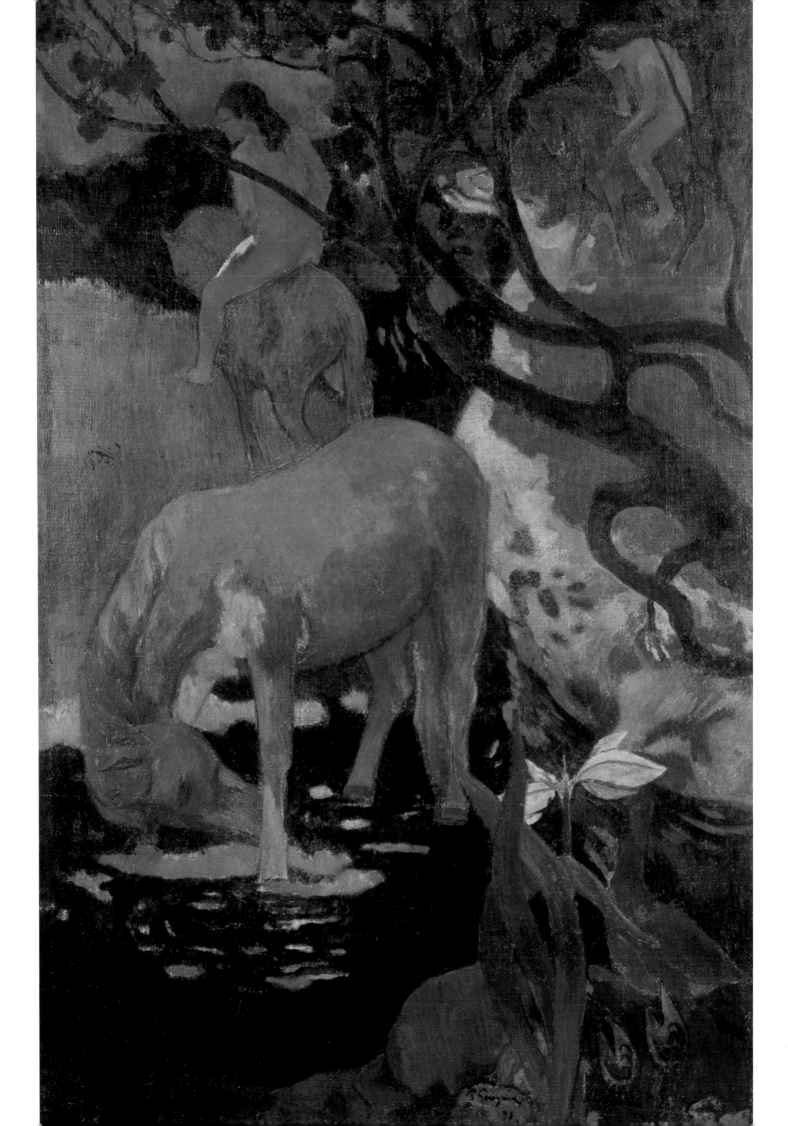

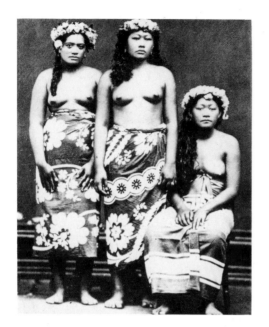

Tahitian Women
Photograph, ca. 1890

blest: "I think everything that ought and ought not to be said about me has been said. All I want is silence, silence, and yet again silence. I want to be left to die peacefully and forgotten."

But Gauguin had not quite turned his back on the world of the living yet. He still had something he wanted to say, so that the contemptuous, mocking crowds would perceive his true worth when he was gone. And so he summoned up all his powers and created his major image of the human condition, *Where Do We Come From? What Are We? Where Are We Going?* (pp. 76/77).

With hardly any preparation he set to work. He had nothing more to lose, and therefore no inhibitions about using his brush with the clumsy crudeness that the critics damned as "over-primitive". He was out to fling one final affirmation of artistic force in the world's face. "I have put all my energy into it one more time before I die," he wrote: "so painful a passion in such dreadful circumstances, so clear and accurate a vision, that there is no trace of precociousness, and life blossoms forth from it." He wanted it to be "comparable with the Gospels": once again, he was ambitiously aiming for that quality of divinity which he so liked to adumbrate in his work, a quality of universality.

The spectrum of human activity encompassed by the painting spans all of life, from birth to death, in all its wondrous diversity. The newborn child lying in the grass, seeing the light of day for the first time, marks one boundary of Gauguin's stage, and the careworn old woman who looks so downcast as she meditates upon the past marks the other. Between the two lies the copious adult world of fears and joys. The exotic idol in the background, and the two people walking (possibly lovers), are there for atmospheric effect, and bridge the gap between Man and the natural setting. Gauguin reveals considerable ambition in the way in which he placed some favourite subjects in his panorama — the relaxed reclining nude, the figures sitting lost in thought, the cult statue. The figures are there to evoke associative meanings, rather than to explain or illustrate. Gauguin was not concerned with being understood: rather, he was interpreting life as a great mystery. The world's lack of understanding, which was pushing him towards suicide, was obliquely expressed in his emphasis of the impenetrable and incomprehensible.

Once he had completed this painting, his testament, Gauguin retreated into the hills to die, like a wounded animal. He took arsenic with him, intending to poison himself. His attempt at suicide was unsuccessful, though. Pathetically enough, Gauguin swallowed too much and promptly vomited the arsenic up again, so that the overdose had no very serious consequences. Somehow or other he managed to get back to town, where he was taken to hospital, a sick man.

Gradually he recovered. His circumstances had not improved, and deportation threatened if he could not pay his debts, so he was obliged to take the kind of routine job he hated so much, working in a creditor's office. In the mean time, Monfreid succeeded in selling *Where Do We Come From? What Are We? Where Are We Going?* The painting, which had proved not to be a testament after all, brought

Two Tahitian Women with Mango Blossoms, 1899
Oil on canvas, 94 × 72 cm
Metropolitan Museum of Art, New York

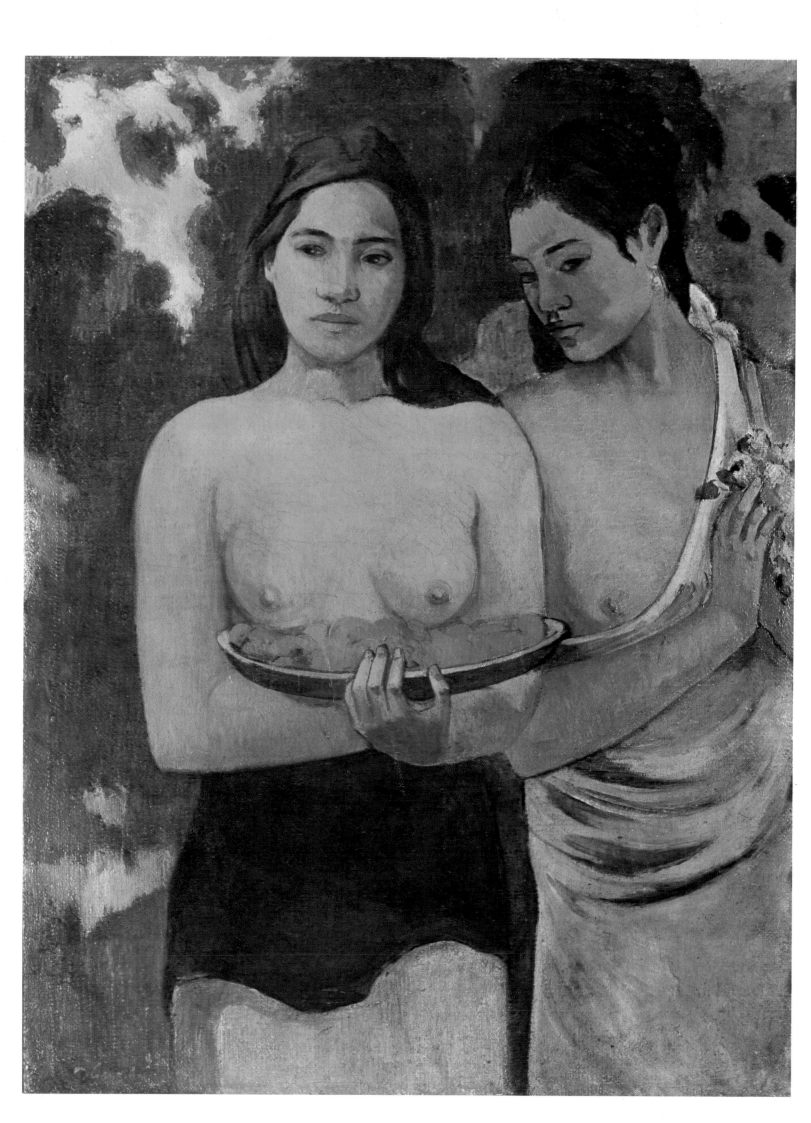

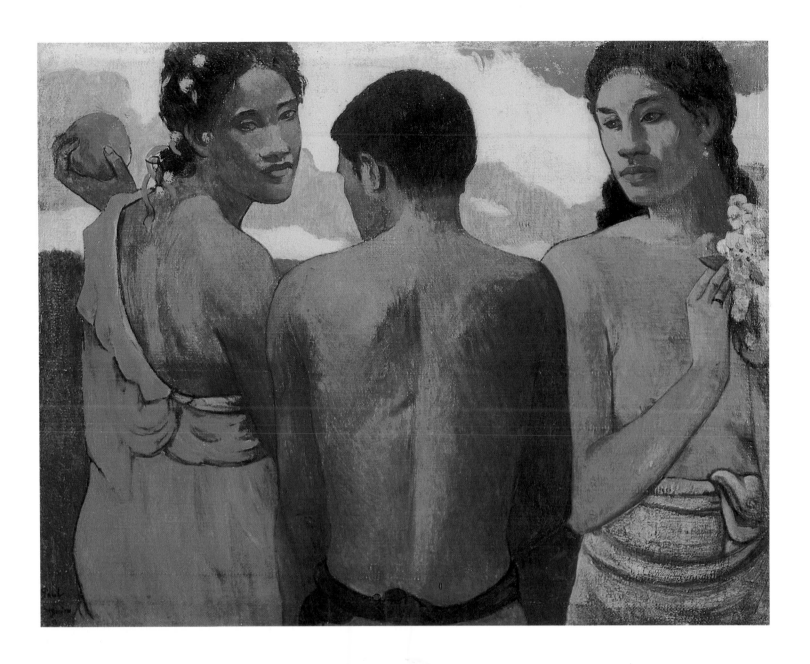

Three Tahitians, 1899
Oil on canvas, 73 × 94 cm
National Gallery of Scotland, Edinburgh

Gauguin a thousand francs. Of all his works, it was the most awkward and unsophisticated that had found a buyer. Gauguin's courage revived.

In the period following these critical months, the artist was calm and relaxed. Indeed, he seemed filled with a blessed tranquillity. As if nothing had happened, his art picked up the familiar motif of the dreamy paradise island again. *The White Horse* (p. 79) is an eloquent example. Painted when Gauguin was convalescing, it reiterates a view of the harmony between Man and Nature as a cure for despair and mortal fear. The animal in the foreground, free of reins, reaching its neck down to the water, communicates a sense of the animal instinctiveness that prevails on the island. Mankind lives in friendship with the beasts. In the background, people are seen riding animals; no lengthy breaking-in has been needed – Man and beast respect each other, and Nature is Man's partner, not his tool. Mutual pleasure in the world is the source of universal happiness. In the period following his breakdown, Gauguin resumed his quest for that state of innocence.

Help from overseas was at hand as well. With the painter's written authority, Monfreid had sold off all Gauguin's pictures for next to nothing. They were bought by the art dealer Ambroise Vollard. Later, Pablo Picasso was to immortalize him in one of his Cubist portraits, but in the closing years of the 19th century there were many who viewed him rather critically, thinking his rapid rise to eminence was due to a preference for good business over good art. And now, in November and December 1898, it was Vollard, of all people, who exhibited the Gauguins he had just acquired for a song. At first Gauguin was vexed. But then Vollard made him the offer he had been waiting longer than a decade for. He guaranteed the painter 2,400 francs a year plus the cost of his materials, and, over and above that, proposed to pay two hundred francs for every painting and thirty for every drawing. Gauguin knew, of course, that a painter friend of his,

**And the Gold of Their Bodies
(Et l'or de leures corps), 1901**
Oil on canvas, 67 × 76 cm
Musée d'Orsay, Paris

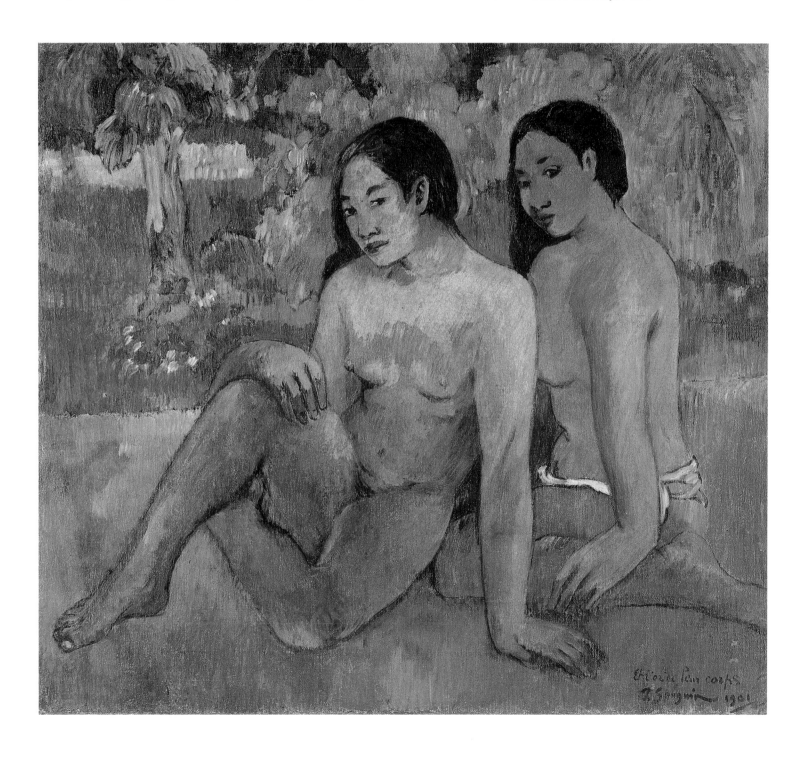

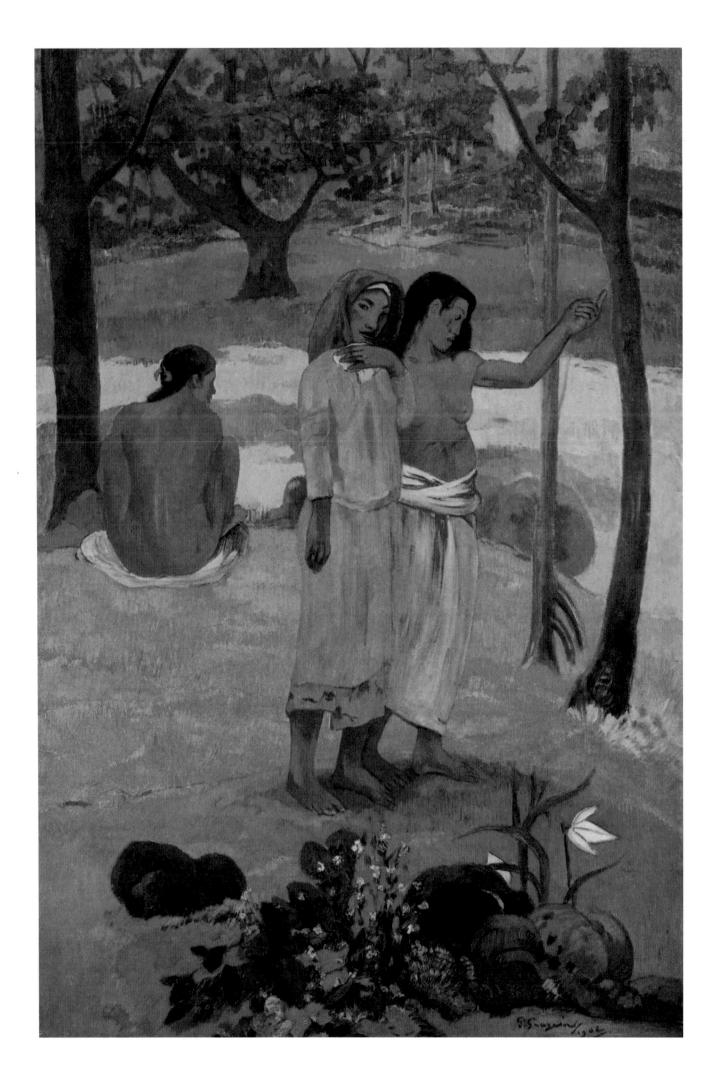

Maurice Denis, had an arrangement worth four times as much; but then, life on Tahiti was far cheaper. From now on, Gauguin would be able to lead a life free of financial cares. Would the door to his earthly paradise be opened at last?

Gauguin's new peace and self-possession increasingly made themselves felt in his choice of motifs. His *Two Tahitian Women with Mango Blossoms* (p. 81) have a monumental dignity of a classical kind. The two women are standing right in the foreground, perfectly naturally, not looking at us, as if they were alone. There is nothing artificial in their pose. They have not been positioned by Gauguin to match figures in art history, as was his habit in his nudes.

With its bright red fruit blossoms, which attract our attention, the picture remains discreet, and wholly devoid of grand gestures. The background setting is totally abstract. In dispensing with a backdrop of suggestive imagery, Gauguin helped his human figures (and the painting) to achieve a quality of charismatic timelessness.

The group of *Three Tahitians* (p. 82) makes the same impression of warm and honest intimacy. They too seem transfigured, and have an almost statuesque presence in this ambience of simplicity. They are neither talking to each other nor attempting to make contact with us; instead, they have a certain monumentality (against a background which is again abstract) — like monuments to the spirit of peaceable contentment. The massiveness of form and solidity of colour areas guarantee the work's rapt dignity. No details mar the vivid stature of the figures of detract from their lively physicality. These are not specific human bodies; these are not individuals; they are symbols of a life of peace and harmony. Gauguin was always out to portray that life; and to emphasize the individual, as European portraiture traditionally does, would not have fitted in with the replete naivety of the existence he was showing.

All in all, Gauguin should have been thriving on Tahiti. He enjoyed recognition and a friendly reception there, and his art was thought valuable and important. A native friend called Jotefa once spoke to him on the matter, and Gauguin recalled the conversation in these terms: "I believe Jotefa is the first person who has said that to me. They were the words of a savage or a child — you have to be one or the other to believe that an artist is performing a useful human task."

On Tahiti he was told what he had longed to hear back home: that art was useful, important, and relevant to everybody. He had travelled halfway round the world, far from *bourgeois* conceptions of art as a trivial pastime, in order to hear this confirmation of his mission, and of his very self.

And yet Gauguin seemed to have only a partial faith in Jotefa's statement, since he saw it as the opinion of a savage or a child. He continued to be divided and distrustful. While he saw the Tahitians as better human beings, he still valued their views less than those of his European contemporaries. If his savages were noble, they were second-class nobility.

His relaxed composure passed. He got entangled in countless legal battles. In the magazine *Les Guêpes,* which he published himself, he

Tahitian Woman, ca. 1900
Pastel, 56 × 49.6 cm
Brooklyn Museum, Brooklyn (N.Y.)

The Call, 1902
Oil on canvas, 130 × 90 cm
Cleveland Museum of Art, Cleveland

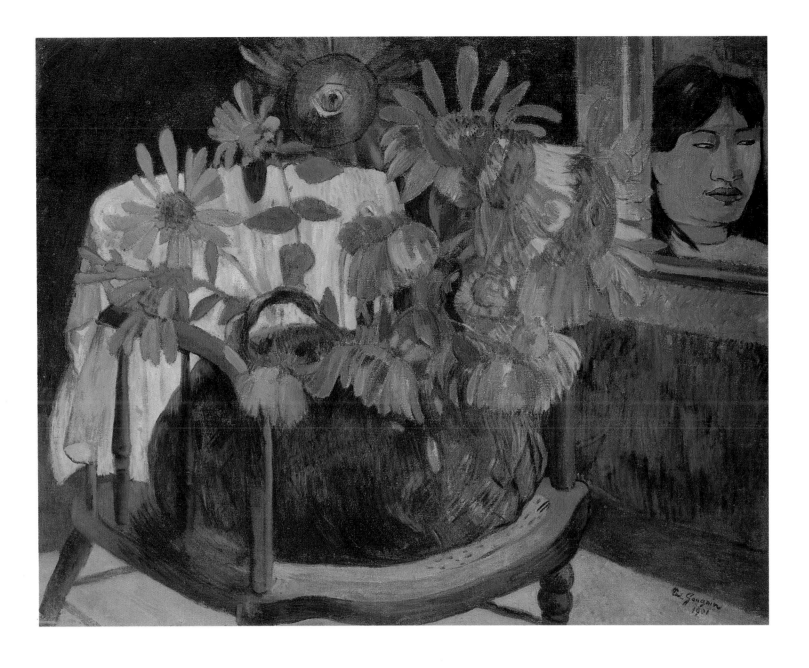

Sunflowers on a Chair, 1901
Oil on canvas, 72 × 91 cm
Hermitage, Leningrad

raged against colonialism, with all its incompetence and corruption, and was promptly inundated with libel suits. Doubtless he meant well in expressing solidarity with the island people, but his typically impetuous and rude outbursts showed that he remained unable to live at peace with himself. His finances were in good shape now, and his health was improving too, so he had to seek out the irritants without which he would have been bored. The magazine had no future, of course, but he promptly started another, called *Le Sourire,* and went on ranting at the colonial authorities, civilization, and indeed the entire world.

Gauguin portrayed the pleasant, amiable side of Tahiti — which had so far escaped the colonialists' clutches — in *Tahitian Idyll* (p. 87). It is the mixture as before — the vegetation, people, and rudimentary huts — but now there is a new dynamic quality in it all. The narrow, red path pours like lava into the foreground, the sense of movement emphasized by the riotous tree-trunks. The picture was to be a last avowal of faith in the island where he had sought an earthly elysium; but the closeness has become ambiguous and the quality of energetic

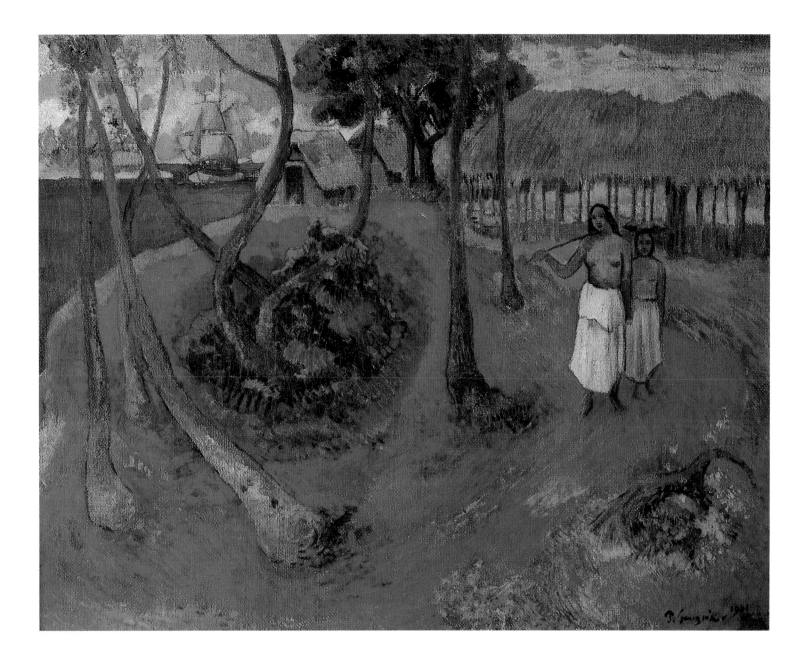

Tahitian Idyll, 1901
Oil on canvas, 74.5 × 94.5 cm
E. G. Bührle collection, Zurich

upheaval in the composition suggests change. And indeed there were changes in Gauguin's life, as he found himself obliged to look for another base in the tropics.

The immediate cause was the rumour of an epidemic in San Francisco. A good number of ships anchored in Tahiti to await developments before continuing to America. Instantly prices soared, and the cheap life which (in Gauguin's eyes) was one of the great advantages of the island was gone. In any case, he was beginning to feel that a change of scene was essential if his art was not to suffer: "My imagination began to flag on Tahiti, and in any case the public was growing too accustomed to Tahiti." Again he was confident: "My Brittany pictures seemed like rosewater after the Tahiti pictures. And once people see pictures from the Marquesas they'll think Tahiti was just eau de cologne."

On 10 September 1901 Paul Gauguin moved to Hiva Oa, the main island in the Marquesas, also a French colony. Gossip had it that his foremost reason for moving was the enforced chastity he was enduring on Tahiti, where the local women no longer found the grumbler

with his gammy leg so attractive. The Marquesas, at any rate, were not on the major shipping lanes and were thus less exposed to the dubious blessings of civilization, and Gauguin soon had a new lover, Marie-Rose Vaeoho by name.

He called his hut 'The House of Pleasure', and soon it was at the centre of a violent controversy. Gauguin had built his little house on land belonging to the Catholic church, but missionaries were as much of a thorn in his flesh as ever, and presently one of his own carvings graced the front garden. It was titled *Father Lecher and Sister St. Theresa.*

As usual, the artist got on best with the native population. Soon they were meeting at his home every evening, carousing and drinking. The church foresaw its flock being dispersed, and the bishop intervened, announcing a ban on visits to the artist. And once again Gauguin was embroiled in legal battles.

The Rev. Vernier, who ran the Protestant school on the island, described him in this way: "He looked like a real Maori, with his colourful native-style loin-cloth and a genuine Tahitian shirt, his feet almost invariably bare, and on his head a green cloth student cap with a silver clasp at the side." And that was the appearance Gauguin presented in court when he faced charges of tax evasion. He refused to pay his taxes on the grounds that he was a savage. He hobbled into the courtroom on crutches, and had to be forcibly removed because he insisted on heckling: Gauguin the angry, anarchist ruffian, fighting for a better world.

The paintings of this period were poetic reminiscences of Arcadia. *Girl with a Fan* (p. 89) is a portrait of Tohotaua, wife of the Hiva Oa witch-doctor, and focusses on the expressiveness of her face. Gauguin based the painting on a photograph, but in the transfer process he purified the image of the chance elements of reality. Again Gauguin borrows from classical art; but this time the savage has the genuinely refined features and distinguishing marks of true civilization. Her body is lit from the top right, while her face is lit from below, as if by torchlight, in theatrical fashion. Though she is a beautiful woman, the corners of her mouth reveal a trace of bitterness, and in her eyes there is melancholy. Her position emphasizes these suggestions of insecurity: her chair appears to be tipping forwards into the depths that yawn this side of the picture's edge.

Two of Gauguin's last works examined riding as a metaphor of the close relationship between man and beast. In *The White Horse* Gauguin had approached the subject circumspectly, presenting it in lusciously overgrown jungle, but in the two paintings titled *Horsemen on the Beach* (pp. 90 and 91) he chose a more open setting: the seashore. Both seashore scenes are given a touch of mystery by the two riders seen in profile, placed parallel to the base-line and obstructing the relaxed movement of the other riders. An unforced sensitivity to the harmony of the human and animal kingdoms takes on a more portentous dimension, and the vividness of these creatures is contained within limits which imply something that lies beyond. A note of discontent can be felt in the work. As in *Girl with a Fan,* dark

Girl with a Fan, 1902
Oil on canvas, 92 × 73 cm
Folkwang Museum, Essen

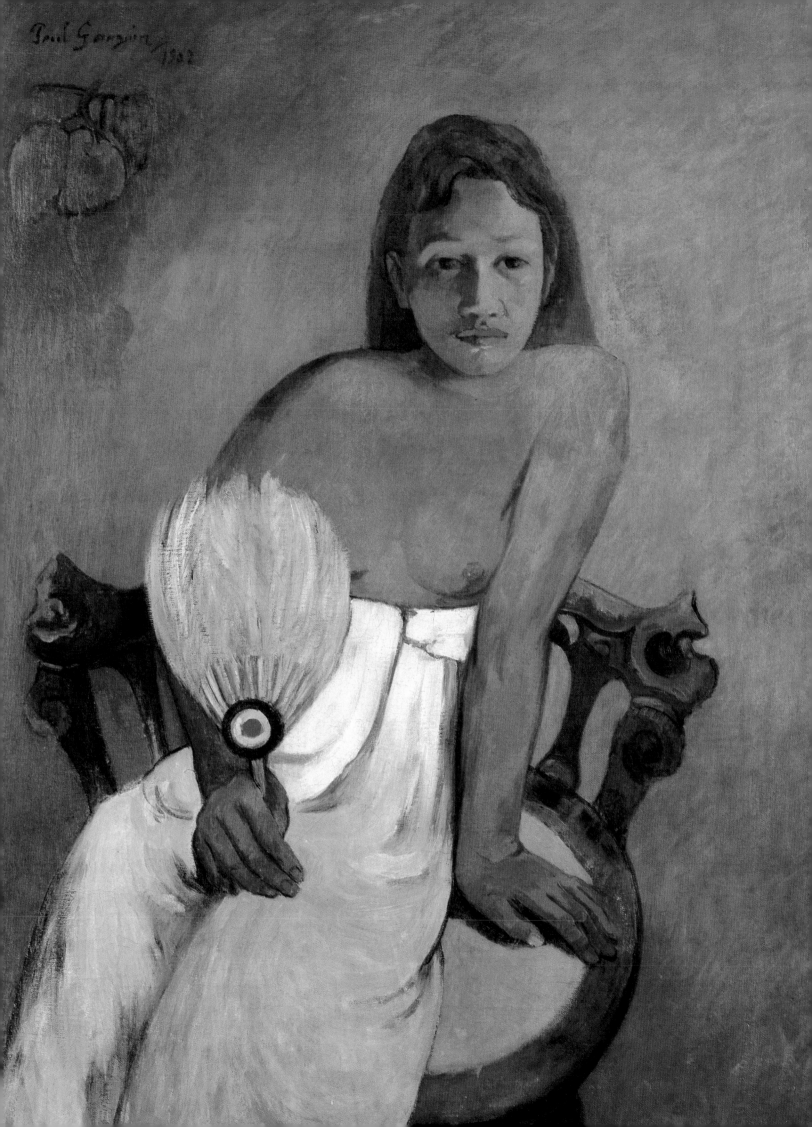

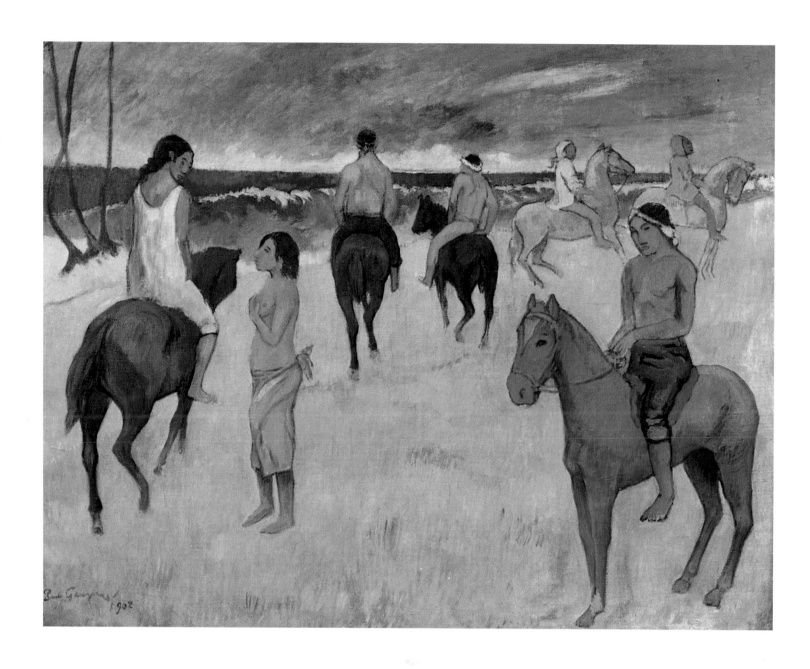

Horsemen on the Beach, 1902
Oil on canvas, 73 × 92 cm
Stavros Niarchos collection

premonitions can be sensed. And the friendly, relaxed ride along the beach somehow only serves to heighten those premonitions.

Barbarous Tales (p. 93) shows how much Gauguin's change of mood had infected his appreciation of the natural, naive world of the islands. The familiar motif of natives relaxing has been expanded to include the brooding figure of a European, one of Gauguin's Paris friends, the poet Meyer de Haan. He is interposed between the peaceful couple and the romantic jungle setting, and is seen contemplating the simple beauty of the two natives with all the ponderousness of the intellectual. And so we see Gauguin projecting into his poet friend his own awareness of the gap between himself and the people he admired. He had failed in his desire to become a savage. And it is this insight that makes *Barbarous Tales* his true testament, rather than *Where Do We Come From? What Are We? Where Are We Going?,* which pretends that all the differences between the cultures might be brushed aside by a pathetic appeal to spirit and life. Gauguin's whole heart was in his attempt to reconcile his love of the tropical world with the needs and wishes of the local people. He was a kind of inverted

missionary. He wanted to be converted by them. But in the last analysis he remained as much a prisoner of his own world as the missionaries who supposed that what was good for them was good for everybody.

The court's verdict in the tax evasion case was now known, and Gauguin was sentenced to three months' imprisonment and a fine of one thousand francs. "I shall have to lodge an appeal on Tahiti. The travel and lodging costs, and above all the lawyer's fee! How much will it come to? It will be the ruin of my finances and of my health. These troubles will be the end of me." Hateful society and its institutions did indeed manage to silence Gauguin. On 8 May 1903 Gauguin, the choleric anti-cleric, sent for a priest. He had had two attacks and wanted the church's final blessing. Soon afterwards he was dead. The priest reported that the natives could be heard wailing: "Gauguin is dead! We are lost!"

Horsemen on the Beach, 1902
Oil on canvas, 65.6 × 75.9 cm
Folkwang Museum, Essen

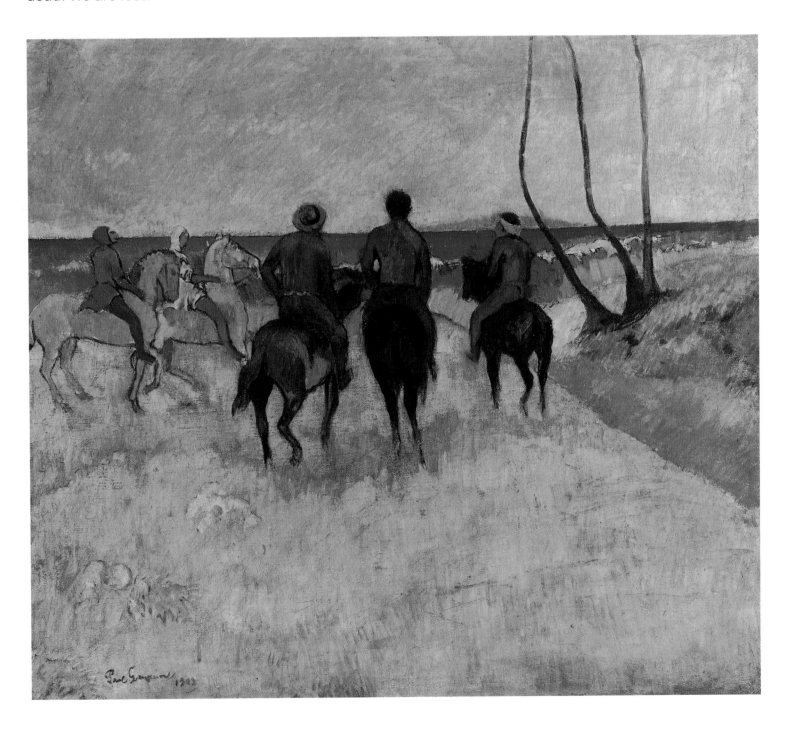

Barbarous Tales, 1902
Oil on canvas, 131.5 × 90.5 cm
Folkwang Museum, Essen

A few days earlier Gauguin had received another letter from Monfreid: "These days you are referred to as that exceptional, magnificent artist who sends in his bewildering but inimitable works from the middle of the Indian Ocean — the creation of a great man who, as it were, has departed this world. You enjoy the immunity of the great dead. You have entered the annals of art history." Gauguin was not to live to relish his triumph. Who can say what his reaction to the world's sudden applause would have been? It was still that hated, unbearable world which he forever wanted to escape. And yet it was in Gauguin and in his rejection of the world that civilization, complex as it is, discovered its own image.

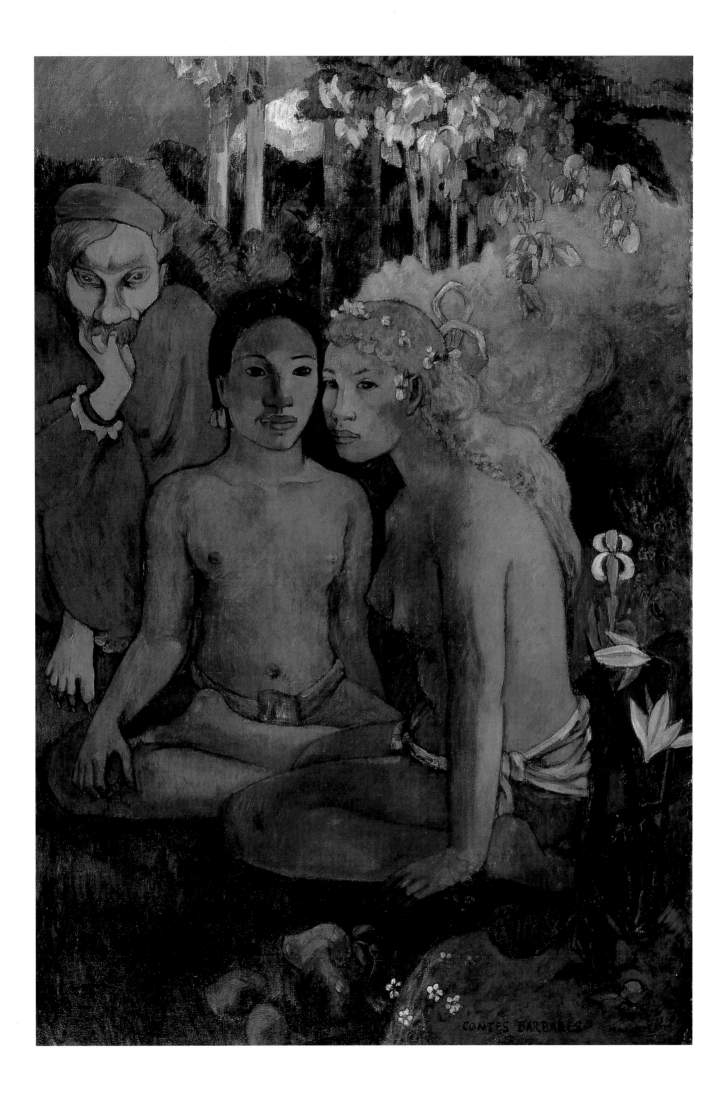

Paul Gauguin 1848–1903
A Chronology

1848 On 7 June Eugène Henri Paul Gauguin is born in Paris, the son of Clovis Gauguin, a Republican editor, and his wife Aline Marie Chazal.

1849 After Louis Napoléon comes to power, the family emigrate to Peru. Gauguin's father dies on the way. The mother and children stay with relatives in Lima.

1855 Return to Uncle Isidore's in Orléans.

1859 Paul goes to the *Petit Seminaire,* a boarding grammar school in Orléans, where he receives his schooling until 1865.

1862 Return to Paris.

1865 Paul goes to sea as a ship's boy on the Luzitano, voyaging between Le Havre and Rio de Janeiro.

1866 Thirteen-month voyage round the world as second lieutenant on the Chili. Death of his mother.

1868 Joins the navy.

1871 Able-bodied seaman aboard a corvette, the Jerôme Napoléon, during the Franco-Prussian War. After the war Gauguin works as a broker's agent at Bertin's in Paris, and meets Claude-Emile Schuffenecker. First drawings.

1872 Gauguin and Schuffenecker study painting and visit the Louvre together.

1873 22 November: Gauguin marries a Danish governess, Mette Sophie Gad.

1874 Visits Pissarro and meets other Impressionists, and collects their paintings. Studies painting at the Colarossi Academy. Son Emil born.

1876 Daughter Aline born. Exhibits at the *Salon* for the first time.

1879 Son Clovis born. Spends summer painting with Pissarro in Pontoise. His bank and stock exchange deals provide a comfortable income and he con-tinues to buy paintings. Exhibits at the fourth Impressionist show.

1880 Rents a studio in the Vaugirard quarter. Exhibits with the Impressionists and the *Indépendents.*

1881 Painting with Pissarro and Cézanne. *Suzanne Sewing* (p. 6) is well received. Son Jean René born.

1882 Exhibits at the seventh Impressionist show.

1883 Quits his stock exchange job. Break with Cézanne. Spends the summer painting with Pissarro in Osny. Birth of fifth child, Pola.

1884 Moves to Rouen, but then in October financial straits force him to move to Mette's parents in Copenhagen. Unsuccessful attempt to be a sailcloth salesman.

1885 Exhibition in Copenhagen is a failure. Falls out with his in-laws and returns to Paris, taking Clovis. Mette stays in Denmark with the children.

Paul Gauguin: *Mette Gauguin in Evening Dress* (detail), 1884. Oil on canvas, 65 × 54 cm. Nasjonalgalleriet, Oslo

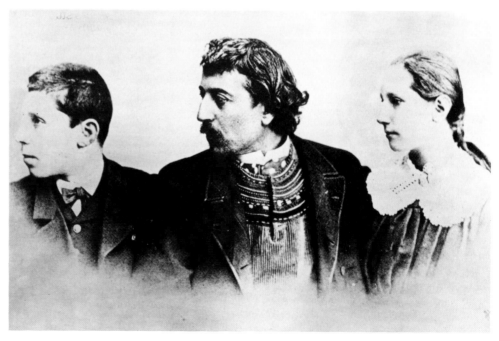

Paul Gauguin with his son Clovis and daughter Aline in Copenhagen, 1885

Gauguin in Paris in front of his painting *Brooding Woman* **(see p. 41), around 1893/94**

Gauguin in 1888

Gauguin with his palette

1886 Working as a bill-poster. Puts Clovis in a *pension* and goes to Pont-Aven in Brittany, where he meets Bernard. Again in Paris he meets Theo and Vincent van Gogh, and Degas. Dreams of travelling to the tropics.

1887 Mette visits him in Paris. In April he and fellow-painter Laval travel to Panama and then Martinique. Both fall ill. Back in Paris he moves in with the Schuffeneckers. Theo van Gogh buys some pictures and ceramic works.

1888 February to October in Pont-Aven with Bernard, Laval and Meyer de Haan. Break with Impressionism. With Bernard he founds "synthetic Symbolism". Paints *Vision after the Sermon* (p. 21). Solo exhibition at Theo van Gogh's gallery. Late autumn with Vincent van Gogh in Arles. Following their misunderstandings he returns to the Schuffeneckers in Paris.

1889 Exhibits twelve paintings with *Les Vingt* in Brussels. Schuffenecker arranges a show at the Café Volpini. In Pont-Aven again, and Le Pouldu. Influences young painters such as Sérusier, Denis and Bonnard.

1890 In Paris until June. Plans to emigrate. Second stay in Le Pouldu. Acquaintance with the Café Voltaire Symbolists: Monfreid, Redon, Mallarmé. Organizes an auction of his paintings to finance his emigration.

1891 Sells thirty paintings at the Hôtel Drouot for 9,860 francs. Quarrel with Bernard. Bids farewell to his family in Copenhagen and friends in Paris and on 4 April takes ship to Tahiti, where he arrives on 28 June. Starts on his autobiographical *Noa Noa*.

1892 Serious illness. He is nevertheless productive and sends seven paintings to Paris.

1893 Eye disease, loneliness and financial distress oblige him to return to Paris early. Uncle Isidore's legacy alleviates his situation. Rents studio in Rue Vercingétorix. Living with Anna the Javanese (see p. 58).

1894 Farewell visit to Copenhagen. April to December with Anna in Brittany. Breaks his ankle in a brawl with sailors.

1895 Second, unsuccessful auction at the Hôtel Drouot. 3 April takes ship for Tahiti a second time.

1896 Builds himself a live-in studio at Punaania. Plagued by illness, depression and financial worries, but still paints numerous masterpieces.

1897 Aline dies. Definitive break with Mette. Serious illness: Gauguin's health has been ruined by alcohol and syphilis. *Noa Noa* published. Paints *Where Do We Come From? What Are We? Where Are We Going?* (pp. 76/77).

1898 Attempts suicide. Hospitalized in Papeete. Takes a job in Paofai until money arrives from Monfreid in Paris.

1899 Editing two satirical journals. His lover Pau'ura gives birth to a son, Emile.

1900 Vollard, a Parisian dealer, offers Gauguin a contract and buys pictures. Improvement in his financial position but again hospitalized. Son Clovis dies.

1901 In the autumn, sells his Tahiti house and moves to Atuana on the island of Dominique in the Marquesas. Builds his 'House of Pleasure' on Catholic mission land.

1902 Quarrels with the church and colonial administration in Atuana. Heart disease and syphilis set him longing for home. Monfreid advises against returning since it would destroy the myth of the South Seas painter.

1903 The refractory Gauguin is sentenced to three months in prison and fined 1,000 francs. He has neither the energy nor the money to defend himself. Before he can begin his sentence he dies on 8 May, aged 54, at his home in Atuana.

The author and publishers would like to thank the museums, collectors, photographers and archives who gave permission to reproduce material. Picture credits: Gruppo Editoriale Fabbri, Milan. André Held, Ecublens. Bildarchiv Alexander Koch, Munich. Walther & Walther Verlag, Alling.